FRIDA

to

A Z

Smith
Street
Books

INTRODUCTION

'Who was Frida Kahlo? It is not possible to find an exact answer. So contradictory and multiple was the personality of this woman, that it may well be said that many Fridas existed ...' – Alejandro Gómez Arias

When Frida Kahlo died in 1954, she wasn't regarded as an icon. Her output was too modest; her paintings too small and personal, too strange in their subject matter. In the span of her brief life, she had only one solo exhibition in her native Mexico and, despite achieving a measure of success in the USA and Paris, to the rest of the world she was unknown. When she died, it seemed as though her legacy would be forgotten.

Decades passed. It wasn't until the 1980s that her work began to be reassessed, to come out of the shadow of her husband Diego Rivera's fame. Frida was a trailblazer whose art powerfully depicted her lived experience, and her life and art began to resonate – with women, with people of colour, with people who identify as queer or live with disability. Like many people touched by genius, she was years ahead of her time.

Her reality was complicated. After a childhood bout of polio and a bus accident in her youth, she was left with medical issues that affected her whole life. Suffering was her constant companion. She lived intensely, painfully, passionately – her life was as rich in love as it was in pain. She wasn't a simple person, nor was she easy. She contained deep contradictions. She was extremely generous but incredibly needy. She was humble about her work but vain about her appearance. She understood the power of spectacle, and used her charms to distract from her broken body. She drank heavily, smoked constantly and swore joyfully. She was an incomparable painter. She was passionately political. She enjoyed causing a scene.

It's impossible to understand Frida without also considering Diego. He was the great love of her life but they had a famously volatile relationship. Both great artists, both ruled by passion, they fought constantly and made up just as often. He was a chronic philanderer and broke her heart over and over again. But she too had affairs, and she fell in love with both men and women. But the most important thing about their relationship wasn't their indiscretions or love affairs: it was their unshakable devotion to one another.

Since her death in 1954, Frida Kahlo has rightly become an icon. Her art is legendary and her name is synonymous with powerful womanhood, fabulous style and not giving a damn what anybody thinks. She absorbed the pain and joy of her experiences and returned them to the world as subversive, intensely personal and electrifying paintings, which remain a powerful testament to her extraordinary life.

NADIA BAILEY

A
is also for

Androgyny

'Of my face, I like the eyebrows and the eyes. Aside from that, I like nothing,' Frida once wrote. 'I have the moustache and in general the face of the opposite sex.' Despite or perhaps because of this, Frida turned her androgynous looks into a source of subversive power. She painted a number of self-portraits in which her moustache is portrayed as more prominent than it was in life, and in one self-portrait, she depicted herself with a boyish haircut, dressed in an oversized men's suit.

...

Addiction

Frida suffered both chronic illness and debilitating physical trauma. She endured more than 30 surgeries and had multiple miscarriages and abortions. To manage her pain, she relied on a cocktail of drugs, including pethidine, morphine and alcohol, and was rarely seen without a cigarette in hand. While her cause of death was officially listed as a pulmonary embolism, some believe that she died by an intentional overdose of drugs. Her final diary entry was ambiguous: 'I hope the exit is joyful – and I hope never to come back – Frida.'

...

Anahuacalli

Early in their marriage, Diego and Frida bought a property in Coyoacán, in the south of Mexico City. Originally they hoped to farm the land but, as it was too swampy, Diego decided to build an ambitious museum on the site. He called it Anahuacalli. Today it showcases his collection of pre-Columbian artefacts alongside his own murals, sketches and mosaics.

Frida's politics extended to real-world action, too: moved by the plight of the Loyalists who were defeated in the Spanish Civil War, she and Diego organised for 400 Spanish refugees to be granted asylum in Mexico.

As a committed revolutionary, Frida liked to claim that she was born in 1910, the same year that the Mexican Revolution began. Actually, she was born three years earlier, in 1907.

Jacobo Árbenz

Frida's last public appearance was to attend a protest march in Mexico in support of Guatemala's left-leaning president Jacobo Árbenz, who had been ousted in a political coup. Although she was ill and in a wheelchair, she took to the streets holding a banner decorated with a peace dove to show her solidarity with the cause.

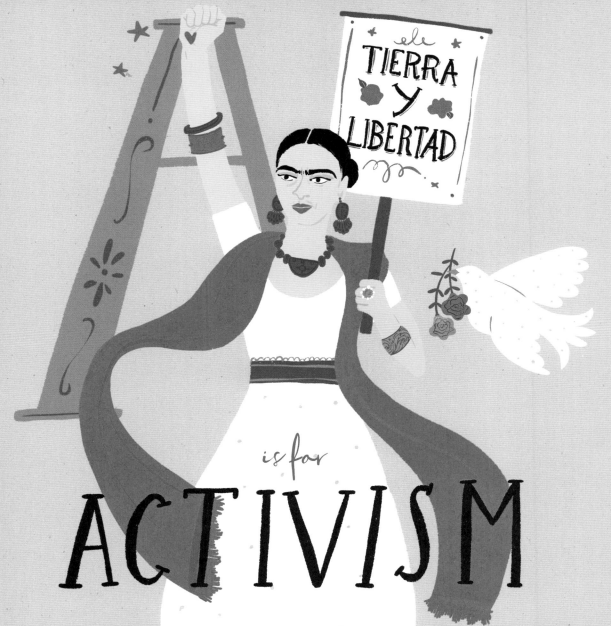

A is for ACTIVISM

Frida Kahlo was a revolutionary right from the start. When she was a teenager, she entered the Escuela Nacional Preparatoria (National Preparatory School) and joined a group known as Los Cachuchas, named for the floppy cloth caps worn by its members. During her school years, she also became active in leftist groups, a political passion she would keep her whole life. After she married Diego Rivera, Frida became even more actively political, and the couple threw their weight behind many causes. They were pro-socialism, anti-capitalism, anti-imperialism and anti-fascism. Diego believed strongly in the power of art to stir revolutionary action, and painted huge murals in service of his revolutionary aims. In her later years, Frida became increasingly concerned about whether her art had achieved the same thing: 'I should struggle with all my strength for the little that ... my health allows me to do in the direction of helping the Revolution,' she wrote in her diary. Using her art as a vehicle for her activism, she declared, was the 'only real reason to live'.

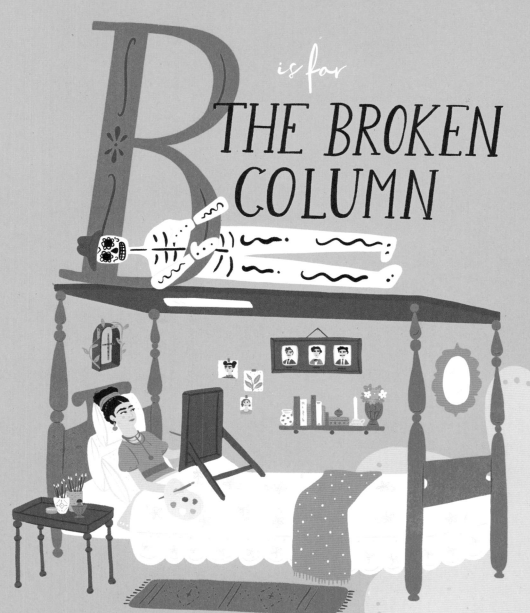

B is for THE BROKEN COLUMN

Of all Frida Kahlo's paintings, the one that most powerfully telegraphs her experience of suffering is *The Broken Column*. Completed in 1944 in the aftermath of one of her many surgeries, it shows Frida standing in a desolate, cracked landscape wearing a steel orthopaedic corset over her bare chest. Her torso is split in two and in the gap is a cracked Ionic column where her spinal column should be. Her body is pierced by nails and tears dot her cheeks, yet her face remains remote and impassive. Like many of Frida's paintings, *The Broken Column* is powerfully autobiographical. On 12 September 1925, she and her boyfriend, Alejandro Gómez Arias, were returning home from school on a wooden bus when a trolley car collided with it. It crushed the bus and killed several people on board. Frida's injuries were catastrophic: her spinal column was broken in three places, several of her ribs were fractured, and her collarbone was broken. Her right leg suffered 11 fractures, her foot was dislocated and crushed, and her shoulder was put out of joint. Worst of all, a steel handrail impaled her through her pelvis, fracturing the bone. The accident altered the course of Frida's life.

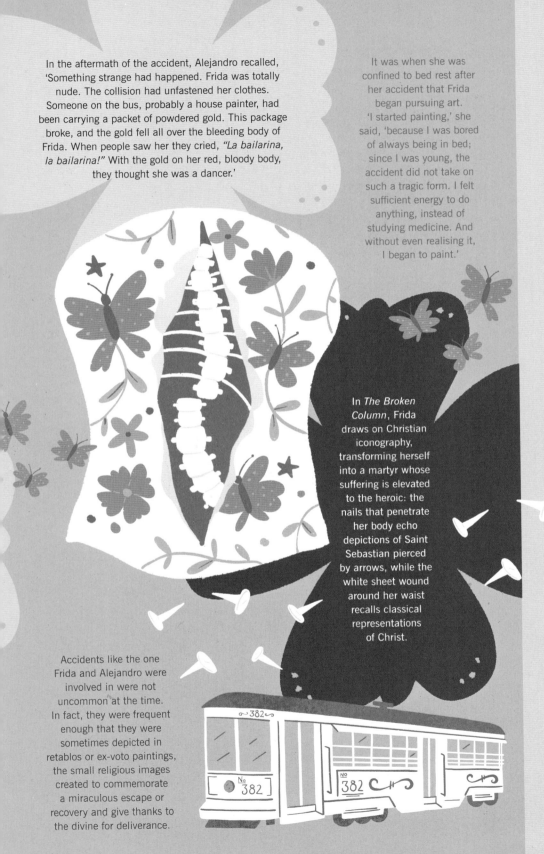

In the aftermath of the accident, Alejandro recalled, 'Something strange had happened. Frida was totally nude. The collision had unfastened her clothes. Someone on the bus, probably a house painter, had been carrying a packet of powdered gold. This package broke, and the gold fell all over the bleeding body of Frida. When people saw her they cried, *"La bailarina, la bailarina!"* With the gold on her red, bloody body, they thought she was a dancer.'

It was when she was confined to bed rest after her accident that Frida began pursuing art. 'I started painting,' she said, 'because I was bored of always being in bed; since I was young, the accident did not take on such a tragic form. I felt sufficient energy to do anything, instead of studying medicine. And without even realising it, I began to paint.'

In *The Broken Column*, Frida draws on Christian iconography, transforming herself into a martyr whose suffering is elevated to the heroic: the nails that penetrate her body echo depictions of Saint Sebastian pierced by arrows, while the white sheet wound around her waist recalls classical representations of Christ.

Accidents like the one Frida and Alejandro were involved in were not uncommon at the time. In fact, they were frequent enough that they were sometimes depicted in retablos or ex-voto paintings, the small religious images created to commemorate a miraculous escape or recovery and give thanks to the divine for deliverance.

B
is also for

André Breton
In 1938, poet and essayist André Breton met Frida and Diego in Mexico. Breton was enchanted by Frida's work, and declared that she was a self-created surrealist. For her part, Frida found Breton irritating and pretentious (she preferred the company of his wife, Jacqueline Lamba) and once referred to him in a letter as 'old cockroach Breton'.

...

Josephine Baker
Josephine Baker was a dancer, an entertainer, a secret spy for the French military, and the inventor of the famous 'Danse Sauvage', which she performed wearing a costume consisting of little more than a skirt made of a string of artificial bananas. Frida and Josephine met in Paris in 1939 and, although there's no firm evidence, Josephine was rumoured to be one of Frida's many lovers.

...

Barbie
In 2018, Mattel released a Barbie doll inspired by Frida Kahlo as part of its 'Inspiring Women' series. But not everyone was happy about it. While the doll had black hair styled with flowers and wore a Mexican-inspired costume, many people felt it failed to do Frida justice, as it failed to represent her tan skin, dark eyes, prominent unibrow and disabled body.

C is also for

Corset

Frida spent much of her life wearing orthopaedic corsets designed to hold her fractured spine in place. Although they were worn out of necessity, she transformed them into works of art, decorating them with colourful paintings of flowers, tigers, monkeys, birds and, in one instance, a foetus and the hammer and sickle found on the Soviet Union's flag.

...

Catholicism

While her mother was deeply religious, Frida didn't subscribe to the Catholic religion. Nevertheless, its influence can be seen throughout her body of work. In one of her most arresting paintings, *Self-Portrait with Thorn Necklace and Hummingbird* (1940), for example, she drew on the iconography of religious suffering by depicting herself wearing a necklace made of thorny vines – a reference to the crown of thorns placed on Jesus' head during his torture and crucifixion.

...

Chronic illness

At six, Frida contracted polio. Her right leg atrophied and was left permanently thinner and shorter than her left leg. As a result of her illness, she became an introverted child who lived in a self-created world of imaginary friends. As an adult, Frida transformed her experience of living with illness and chronic pain into art: there, she was free to create a world without boundaries.

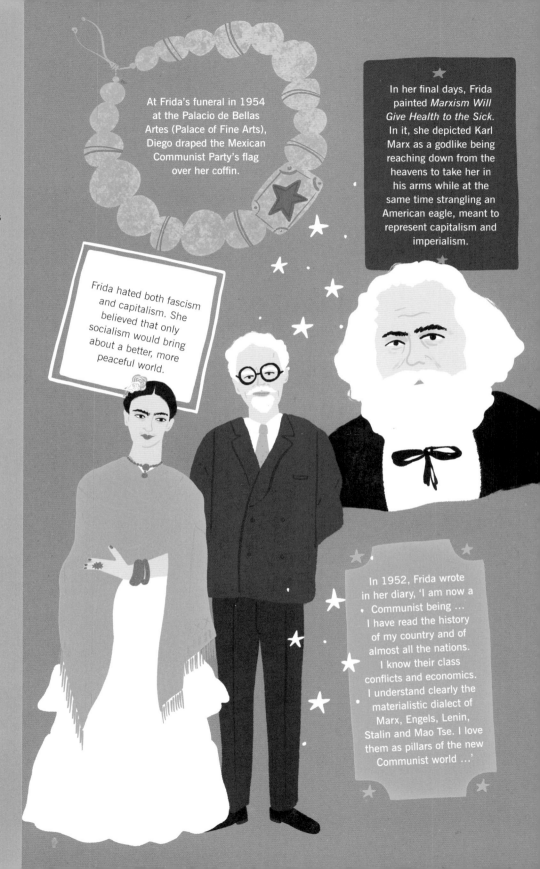

At Frida's funeral in 1954 at the Palacio de Bellas Artes (Palace of Fine Arts), Diego draped the Mexican Communist Party's flag over her coffin.

In her final days, Frida painted *Marxism Will Give Health to the Sick*. In it, she depicted Karl Marx as a godlike being reaching down from the heavens to take her in his arms while at the same time strangling an American eagle, meant to represent capitalism and imperialism.

Frida hated both fascism and capitalism. She believed that only socialism would bring about a better, more peaceful world.

In 1952, Frida wrote in her diary, 'I am now a Communist being ... I have read the history of my country and of almost all the nations. I know their class conflicts and economics. I understand clearly the materialistic dialect of Marx, Engels, Lenin, Stalin and Mao Tse. I love them as pillars of the new Communist world ...'

C is for

COMMUNITY

Frida Kahlo was born in a volatile time. The Mexican Revolution began in 1910 when she was three years old, and lasted nearly a decade. By the time she was a teenager, it had resulted in a dramatic shift in Mexican politics and culture. A new constitution brought reforms such as better conditions for workers, equal pay for women, and the introduction of socialist ideals. Throughout her life, Frida was passionate about her political communities and her principles were reinforced through her relationship with Diego Rivera. In the 1930s, they persuaded the Mexican president Lázaro Cárdenas to grant political asylum to Trotsky and his wife Natalia Sedova. The exiled Russians came to live with Frida and Diego; Trotsky became infatuated with Frida and the two had an affair. Eventually, Diego had a falling-out with Trotsky over political differences, and his sympathies switched back to Stalin.

D is for DUALITY

Life versus death, masculine versus feminine, light versus dark, ancient versus modern – if there's one thing that defined Frida Kahlo's work, it was her enduring obsession with duality. This duality was felt in many aspects of her life: her father's atheism and her mother's devout religiosity; her European versus her Mexican heritage; her natural tendency towards *alegría* (joy, humour and verve for life) versus the constant physical pain she suffered. She powerfully expressed her duality in *The Two Fridas* (1939), which she created while her marriage to Diego was breaking down. In it, Frida painted herself doubled. One Frida is dressed in European clothing, her heart exposed and broken, and she is holding a pair of bloodied forceps. The other wears traditional Mexican dress and holds a small portrait of Diego, and her exposed heart is whole. Frida shows herself split into two beings: perhaps the European Frida versus the Tehuana Frida, or perhaps the Frida whom Diego loved versus the Frida whom Diego divorced.

Frida's obsession with duality is echoed across Mexican culture and mythology. Life and death, light and darkness, past and present, day and night, male and female are just some of the dichotomies she drew on in her work.

Frida sometimes expressed her duality through the use of composite beings. In *Diego and Frida* (1944), she painted herself and Diego as two halves of a whole, while in *Self-Portrait as a Tehuana* (1943) and *Diego and I* (1949), Diego appears superimposed over her, suggesting a symbiotic or dual existence.

Frida's sense of duality may have stemmed from her accident. Her friend Lola Álvarez Bravo believed that Frida felt as if she became two distinct people that day: 'The struggle of the two Fridas was in her always – the struggle between one dead Frida and one Frida that was alive.'

Many of Frida's paintings depict being caught between two worlds. In *Self-Portrait on the Borderline Between Mexico and the United States* (1932), Frida stands on the border between her home country and the USA. The sun and moon appear in the sky on the Mexican side of the painting, which is vibrant with plants and flowers; the American side is dominated by smokestacks and factories. Frida stands caught in the middle – but there's little question as to where her loyalties lie.

D is also for

Detroit
Frida and Diego lived in Detroit in 1932 after Diego was commissioned by the Detroit Institute of Arts to create a series of murals on modern industry. Frida did not take to the city. 'I don't like it at all,' she wrote to her doctor. 'The industrial part of Detroit is really most interesting, the rest is, as in all of the United States, ugly and stupid.'

...

Divorce
Frida and Diego's relationship was tumultuous: passionate, angry, full of betrayals and reconciliations. In 1939, after ten years of marriage, they initiated divorce proceedings. When asked why, Frida was vague, citing 'intimate reasons, personal causes, difficult to explain'. The divorce did not last long: on 8 December 1940, the day of Diego's 54th birthday, the two got married again.

...

Diary
Frida's diary, which she kept from the mid-1940s, is a work of art in itself, featuring drawings, pen-and-ink sketches, gouache paintings, surreal poetry and numerous self-portraits. Produced during the last ten years of her life, it also pays vivid tribute to her bond with Diego and expresses all the emotions she felt during their relationship: elation, betrayal, devotion, desire, longing and joy.

...

Dolls
Frida loved dolls, often rescuing shabby and dirty specimens from flea markets and caring for them as if they were surrogate children. Some even had mocked-up baptism certificates that named Frida as their mother.

E

is also for

Epilepsy

Frida wasn't the only person in her family to live with disability: her father, Guillermo Kahlo, developed epilepsy after he sustained brain injuries in a fall. Because of this shared experience, Frida and her father developed a special bond – while he loved all his children, she was said to be his favourite.

...

Enagua

Frida's signature long skirts are called *enagua* and are part of the traditional dress of Mexico's Indigenous Tehuana women. The choice was more than just aesthetic – the long, flowing skirts covered her leg stunted by polio, and their elegant, swinging motion helped conceal her limp. Such was their significance in her life that her disembodied outfits make symbolic appearances in paintings such as *My Dress Hangs There* (1933) and *Memory, the Heart* (1937), standing in for Frida herself.

...

Easel

Frida's first paintings were made while she was recovering from the bus accident. As she was unable to move most of her body, she needed an easel that could be used while she was lying down. 'My mother asked a carpenter to make an easel, if that's what you'd call a special apparatus that could be attached to my bed where I lay, because the plaster cast did not allow me to sit up,' Frida recalled. 'In this way, I started to paint.' In 1950, when she underwent a series of spinal surgeries, she had a similar easel installed over her hospital bed, which allowed her to work for four or five hours a day.

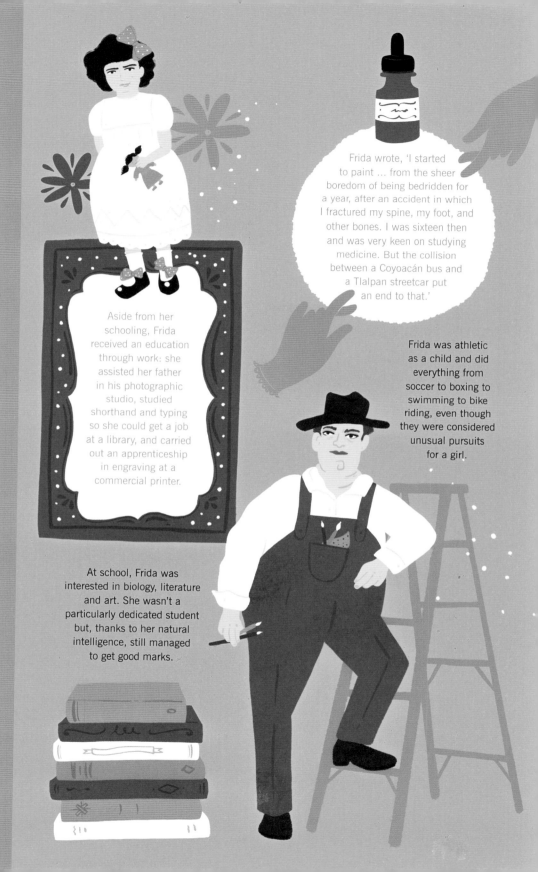

Frida wrote, 'I started to paint ... from the sheer boredom of being bedridden for a year, after an accident in which I fractured my spine, my foot, and other bones. I was sixteen then and was very keen on studying medicine. But the collision between a Coyoacán bus and a Tlalpan streetcar put an end to that.'

Aside from her schooling, Frida received an education through work: she assisted her father in his photographic studio, studied shorthand and typing so she could get a job at a library, and carried out an apprenticeship in engraving at a commercial printer.

Frida was athletic as a child and did everything from soccer to boxing to swimming to bike riding, even though they were considered unusual pursuits for a girl.

At school, Frida was interested in biology, literature and art. She wasn't a particularly dedicated student but, thanks to her natural intelligence, still managed to get good marks.

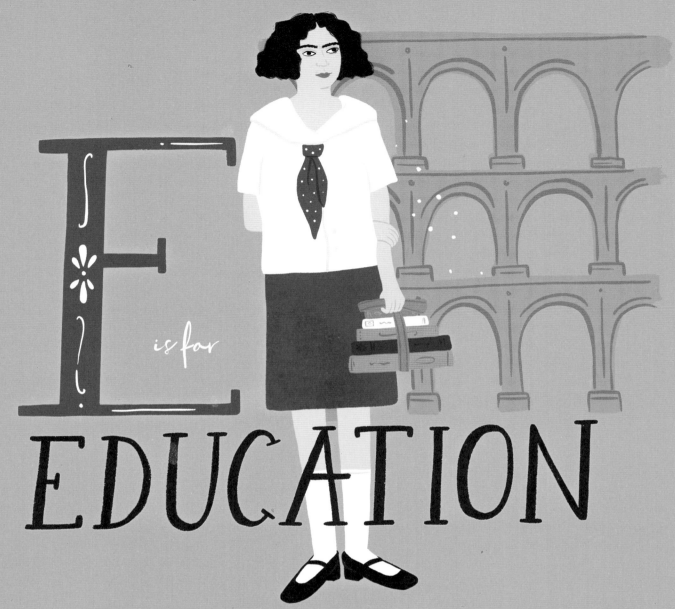

E is for EDUCATION

Frida Kahlo's education began at home. Her mother, Matilde Calderón y González, taught her traditional domestic skills such as how to cook, clean, sew, embroider, and keep a beautiful and functional home. However, Matilde's attempt to teach her daughter religious piety was less successful: Frida took after her father, who was an atheist. In 1922, Frida enrolled at the Escuela Nacional Preparatoria (National Preparatory School), which was considered the best educational institution in Mexico, and chose a course of study meant to lead her to medical school. She was one of only 35 female students in a cohort of over 2000, but she quickly found a clique: a band of seven boys and two girls who were known as Los Cachuchas. It was during her school years that Frida first met Diego Rivera, who had been commissioned to paint a mural for the school's auditorium. At the time, Diego was 36 years old, married to Lupe Marín and already one of Mexico's most famous artists, while Frida was a 15-year-old student. According to legend, she became infatuated with him immediately and declared to her friends that one day she would have his baby. The two didn't strike up a real acquaintance until 1928.

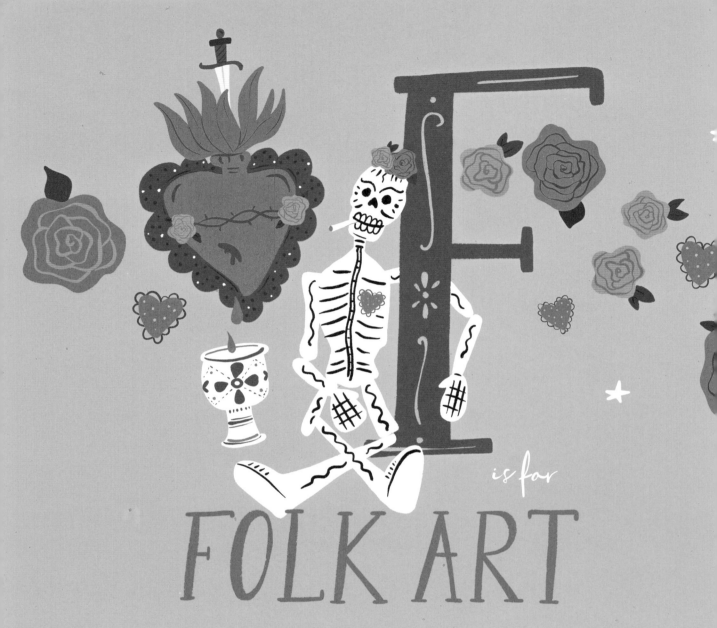

is for

FOLK ART

Frida Kahlo grew up in a time of volatile change in Mexico. After the Mexican Revolution, there was renewed interest in pre-Columbian art, as well as art created by working-class people and traditional indigenous artefacts and handicrafts. Frida and Diego collected ancient Toltec, Mayan and Aztec idols, and filled their home with *arte popular* – traditional Mexican folk art that includes strange papier-mâché creatures called *alebrijes*, devotional retablos painted on metal, decorative terracotta statues, embroidered textiles and children's toys. In post-revolution Mexico, these objects weren't seen as curios or junk; instead, they represented an accessible form of art that was free from the 'elitist values' of the European tradition. A work like *Four Inhabitants of Mexico* (1938) summed up Frida's love of *arte popular*. In it, she painted herself as a child accompanied by four figures: a pre-Columbian Nayarit idol, a Judas figure, a clay skeleton and a straw horseman. Each figure was modelled after a Mexican artefact that Frida and Diego actually owned, and each represented a facet of Mexican identity.

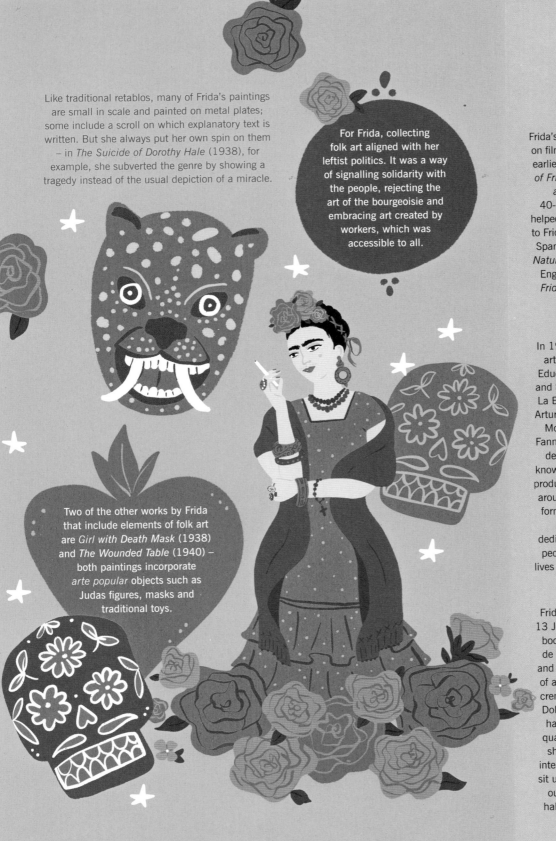

Like traditional retablos, many of Frida's paintings are small in scale and painted on metal plates; some include a scroll on which explanatory text is written. But she always put her own spin on them – in *The Suicide of Dorothy Hale* (1938), for example, she subverted the genre by showing a tragedy instead of the usual depiction of a miracle.

For Frida, collecting folk art aligned with her leftist politics. It was a way of signalling solidarity with the people, rejecting the art of the bourgeoisie and embracing art created by workers, which was accessible to all.

Two of the other works by Frida that include elements of folk art are *Girl with Death Mask* (1938) and *The Wounded Table* (1940) – both paintings incorporate *arte popular* objects such as Judas figures, masks and traditional toys.

is also for

Films

Frida's life has been immortalised on film several times. One of the earliest was *The Life and Death of Frida Kahlo as Told to Karen and David Crommie*, a 40-minute documentary that helped introduce a new audience to Frida in the 60s and 70s. The Spanish-language movie *Frida, Naturaleza Viva* (1983) and the English-language blockbuster *Frida* (2002) also helped her reputation grow.

...

Los Fridos

In 1943, Frida began teaching art at the Ministry of Public Education's School of Painting and Sculpture, better known as La Esmeralda. Four students – Arturo García Bustos, Guillermo Monroy, Arturo Estrada and Fanny Rabel – were particularly devoted to her and became known as Los Fridos. The group produced several outdoor murals around the city and went on to form the Young Revolutionary Artists, an organisation dedicated to bringing art to the people. Los Fridos spent their lives authenticating Frida's work.

...

Funeral

Frida died in the early hours of 13 July 1954. That evening, her body was taken to the Palacio de Bellas Artes in Mexico City and then carried in a procession of around 500 mourners to the crematorium at the Panteón de Dolores. Frida's final moments had a surreal, almost mythic quality. Witnesses said that as she entered the furnace, the intense heat caused her body to sit up and her blazing hair stood out from her face like a fiery halo. It's said she appeared to be smiling.

G

is also for

Alejandro Gómez Arias

As a teenager, Frida fell in love with Alejandro Gómez Arias, a fellow student at the Escuela Nacional Preparatoria. He was with her when she suffered her terrible accident, and it was for him she painted her first self-portrait. They were lovers for several years until Frida fell for Diego Rivera. But the two remained lifelong friends.

...

Gangrene

In 1950, Frida's doctor diagnosed her with gangrene and recommended that her toes be amputated. By the time she actually went through with the surgery, unfortunately the infection had spread and her whole lower leg had to go. Afterwards, Frida used a wheelchair and then learned how to walk again using crutches and a prosthetic leg.

...

Gender

Frida was radically unconventional in a time and culture when strict gender roles were more commonly enforced. But she did everything on her own terms (including how she conducted her marriage with Diego): she pursued schooling, took her art seriously, happily dressed in stylish men's clothing, worked towards financial independence, and pursued love affairs with both men and women.

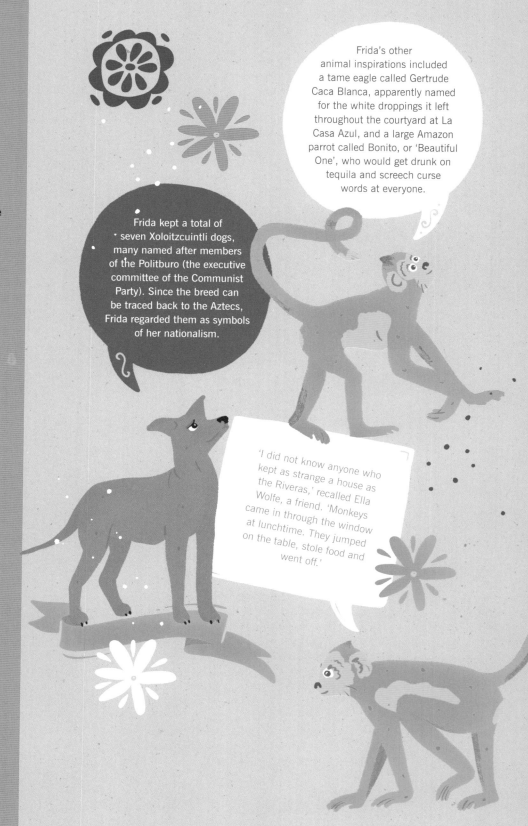

Frida's other animal inspirations included a tame eagle called Gertrude Caca Blanca, apparently named for the white droppings it left throughout the courtyard at La Casa Azul, and a large Amazon parrot called Bonito, or 'Beautiful One', who would get drunk on tequila and screech curse words at everyone.

Frida kept a total of seven Xoloitzcuintli dogs, many named after members of the Politburo (the executive committee of the Communist Party). Since the breed can be traced back to the Aztecs, Frida regarded them as symbols of her nationalism.

'I did not know anyone who kept as strange a house as the Riveras,' recalled Ella Wolfe, a friend. 'Monkeys came in through the window at lunchtime. They jumped on the table, stole food and went off.'

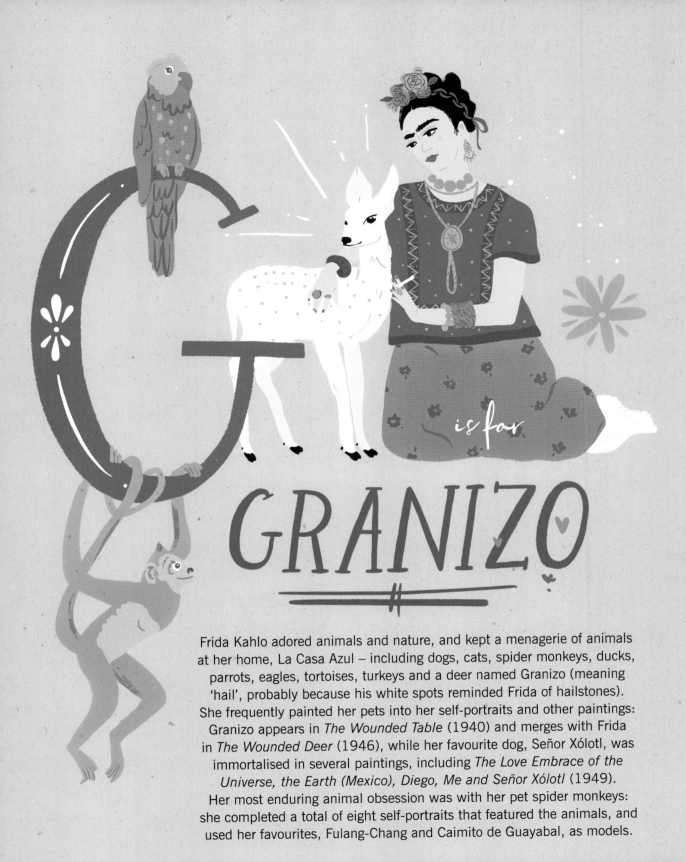

G is for GRANIZO

Frida Kahlo adored animals and nature, and kept a menagerie of animals at her home, La Casa Azul – including dogs, cats, spider monkeys, ducks, parrots, eagles, tortoises, turkeys and a deer named Granizo (meaning 'hail', probably because his white spots reminded Frida of hailstones). She frequently painted her pets into her self-portraits and other paintings: Granizo appears in *The Wounded Table* (1940) and merges with Frida in *The Wounded Deer* (1946), while her favourite dog, Señor Xólotl, was immortalised in several paintings, including *The Love Embrace of the Universe, the Earth (Mexico), Diego, Me and Señor Xólotl* (1949). Her most enduring animal obsession was with her pet spider monkeys: she completed a total of eight self-portraits that featured the animals, and used her favourites, Fulang-Chang and Caimito de Guayabal, as models.

H

is for

HENRY FORD HOSPITAL

On 21 April 1932, Frida Kahlo and Diego Rivera arrived in Detroit. Diego had been commissioned by the Detroit Institute of Arts to complete a series of murals on the theme of modern industry. Frida, who was newly pregnant, considered having an abortion because of her ongoing physical issues, but she desperately wanted a baby and decided to go through with the pregnancy. Ten weeks later, on the evening of 3 July, she began bleeding profusely. By the early hours of the next morning it was clear she was miscarrying, and she was rushed to the city's Henry Ford Hospital by ambulance. The miscarriage affected her both physically and emotionally: she spent 13 days in the hospital in terrible pain, mourning her lost child and trying to come to terms with the fact that she might never be able to have children. But she also wanted to work. She asked for pencil and paper and, copying from a medical textbook, made several careful studies of a male foetus. Later that month, she completed *Henry Ford Hospital* (1932).

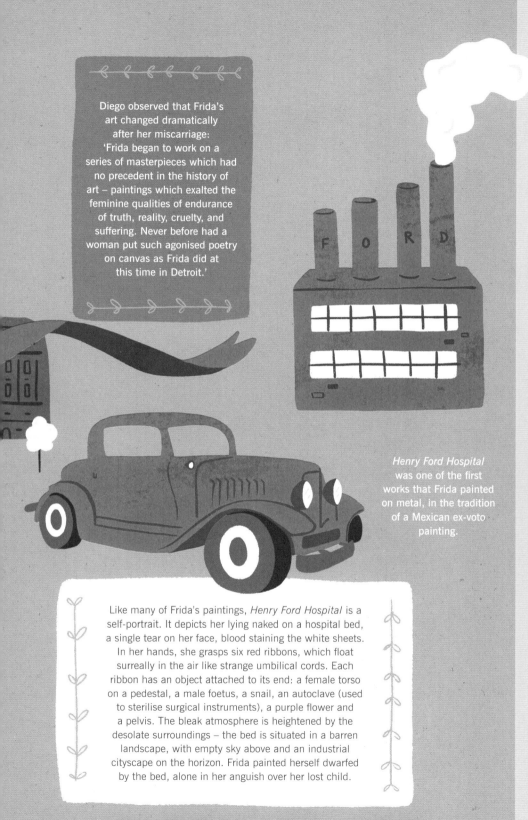

Diego observed that Frida's art changed dramatically after her miscarriage: 'Frida began to work on a series of masterpieces which had no precedent in the history of art – paintings which exalted the feminine qualities of endurance of truth, reality, cruelty, and suffering. Never before had a woman put such agonised poetry on canvas as Frida did at this time in Detroit.'

Henry Ford Hospital was one of the first works that Frida painted on metal, in the tradition of a Mexican ex-voto painting.

Like many of Frida's paintings, *Henry Ford Hospital* is a self-portrait. It depicts her lying naked on a hospital bed, a single tear on her face, blood staining the white sheets. In her hands, she grasps six red ribbons, which float surreally in the air like strange umbilical cords. Each ribbon has an object attached to its end: a female torso on a pedestal, a male foetus, a snail, an autoclave (used to sterilise surgical instruments), a purple flower and a pelvis. The bleak atmosphere is heightened by the desolate surroundings – the bed is situated in a barren landscape, with empty sky above and an industrial cityscape on the horizon. Frida painted herself dwarfed by the bed, alone in her anguish over her lost child.

H
is also for

Huipil
A *huipil* is a loose-fitting, square-cut tunic, usually made from cotton and often embroidered with intricate patterns. As with all of Frida's clothing, the *huipil* served a dual purpose for her: it both embodied her love of pre-Columbian Mexican culture and allowed her to elegantly disguise the orthopaedic corsets she had to wear to keep her fractured spine in place.

...

Dorothy Hale
In 1938, Clare Boothe Luce commissioned Frida to paint a portrait of her friend Dorothy Hale, a beautiful New York socialite who had died by suicide. Instead of a traditional portrait, Frida decided to depict Dorothy's suicide in three stages: first, as she steps off the balcony of a high-rise building; then in mid-fall; and finally lying dead on the ground, with her blood spilling from the bounds of the canvas and onto the painting's frame. When Frida delivered the completed painting, Clare was horrified and wanted to destroy it. Luckily a friend talked her out of that and the painting was saved.

...

Headwear
Part of Frida's Tehuana image was her elaborate hairdos – she almost always wore her hair in the traditional braided style of the Zapotec women, adorned with flowers, combs and ribbons. She often wore fresh sprays of fuchsia, bougainvillea or geraniums, and braided bright skeins of wool or colourful ribbons through her locks.

I

is also for

Infidelity

Frida and Diego's marriage was unconventional. Diego was a serial womaniser who took models, actresses, assistants and even Frida's sister Cristina to his bed. Meanwhile, Frida conducted her own affairs with Leon Trotsky, Nickolas Muray, Isamu Noguchi, Chavela Vargas, José Bartoli, Heinz Berggruen and others.

...

Imaginary friend

After Frida was stricken with polio, she transformed from an outgoing, mischievous child to someone much more introspective. It was around this time that she had an imaginary friend. 'I must have been 6 years old when I experienced intensely an imaginary friendship with a girl more or less the same age as me,' she wrote in her diary. 'Thirty-four years have passed since I experienced this magic friendship and every time that I remember it, it revives and becomes larger and larger inside my world.'

...

The Indian Frida Kahlo

The lives of Frida and artist Amrita Sher-Gil share striking similarities. Amrita was of mixed heritage: her father was an Indian Sikh and her mother a Hungarian Jew. She knew her own mind from an early age and was expelled from her convent school after declaring herself an atheist. She felt an affinity with the working class, and pursued love affairs with both men and women. She became an artist of significant talent who is now hailed as a pioneer of modern art. It's no wonder that she's sometimes called 'the Indian Frida Kahlo'.

More than six decades after her death, Frida means many things to many different people. She's become an icon to feminists, the LGBTIQ+ community, people living with disability, socialists (and, more broadly, the political left) and the chronically ill.

While it's unclear whether Frida self-identified with any marginalised group, her refusal to be silenced and the way she commanded her personal style speak for themselves. She was sometimes regarded as difficult – which is another way of saying that she knew exactly what she wanted from life.

Frida's friend Gisèle Freund described her as someone who loved life and loathed pretension. 'Her entire personality radiates a lively intelligence, a profoundly human spirit, and an exuberant vitality,' she said. 'She hates anything snobbish, anything fake, anything conventional and affected.'

I is for IDENTITY

Frida treated the facts of her life as if they were only a starting point, freely embellishing and altering her history to suit her self-created narrative. She claimed she was born in 1910 rather than 1907 so that her birthdate aligned with the beginning of the Mexican Revolution. She altered the spelling of her name (sometimes going by Frida and sometimes by Frieda) or introduced herself as Carmen. And she claimed Jewish ancestry through her paternal line. Whether her father, Guillermo Kahlo, was actually Jewish remains the subject of scholarly debate (Frida may have invented her Hungarian–Jewish background to detract attention from her German ancestry, which became a source of shame during World War II). As a mixed-race, queer, disabled woman living in a time when any kind of difference was regarded with suspicion, Frida didn't run from what she was: she embraced it. Acutely aware of the power of image-making, she was adept at self-creation — and never let the facts get in the way of a good story.

Frida Kahlo wore jewellery on nearly every part of her body: hair decorated with combs, ears with elaborate earrings, multiple necklaces strung around her neck, arms clustered with bangles, and every finger covered with rings. She favoured three distinct styles of jewellery: ancient, heavy pieces, often in jade or stone, dating from the pre-Columbian era; delicate regional jewellery, most often in gold, which complemented her traditional Tehuana dress; and contemporary silver jewellery made by local designers and craftspeople. She had a way of mixing these pieces with cheap costume jewellery she collected while travelling and, as her friend Lucienne Bloch noted, somehow she'd 'make it look fantastic'. Her eye for jewellery was legendary and her collection attests to her unique taste: bangles cut from the rims of large shells, a pre-Columbian pendant in the shape of a winged creature, a long gold necklace hung with an American 20-dollar coin dating from 1903, and a pair of figural earrings in the shape of hands, given to her by Pablo Picasso.

J is for

JEWELLERY

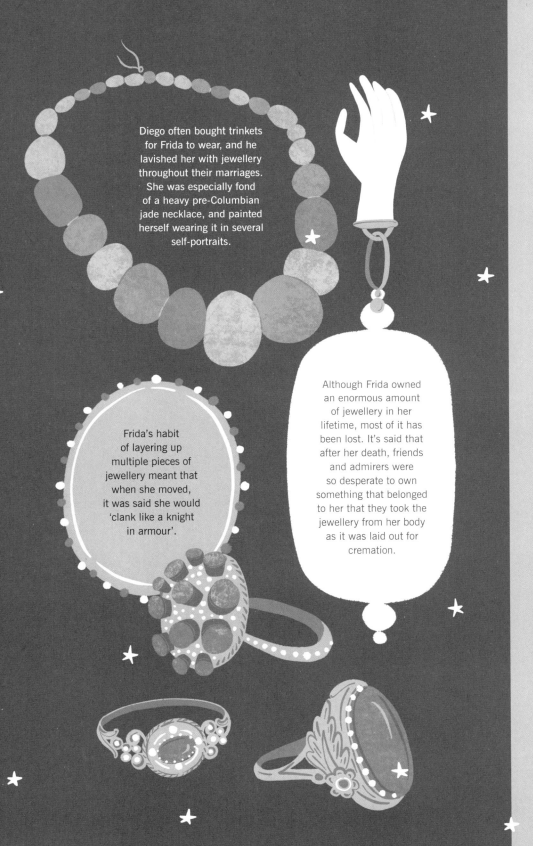

Diego often bought trinkets for Frida to wear, and he lavished her with jewellery throughout their marriages. She was especially fond of a heavy pre-Columbian jade necklace, and painted herself wearing it in several self-portraits.

Frida's habit of layering up multiple pieces of jewellery meant that when she moved, it was said she would 'clank like a knight in armour'.

Although Frida owned an enormous amount of jewellery in her lifetime, most of it has been lost. It's said that after her death, friends and admirers were so desperate to own something that belonged to her that they took the jewellery from her body as it was laid out for cremation.

J *is also for*

Julien Levy Gallery
In 1938, Frida had her first solo show at the Julien Levy Gallery in New York. The show included 25 paintings and was accompanied by a catalogue essay written by André Breton. The press release described her work as having 'an unusual female frankness and intimacy' and noted that it was 'decidedly important and threatens even the laurels of her distinguished husband'. The show received coverage (not all of it positive) in the *New York Times*, *Vogue* and *Time* magazine and about half the paintings sold – an extraordinary number for the Depression years.

...

Judas effigy
Frida and Diego regarded *arte popular* (Mexican folk art) as true artworks rather than mere junk or curios, and filled their home at La Casa Azul with traditional handicrafts and artefacts. This included a number of Judas effigies – large, papier-mâché figures, sometimes modelled into devils or skeletons, which were blown up or burned at popular festivals as an act of cleansing. La Casa Azul featured Judas effigies on display alongside Frida and Diego's art, hanging from the ceiling and even atop the canopy over Frida's bed.

K

is also for

Wassily Kandinsky

While the surrealists and the Parisian art world were charmed by Frida during her 1939 visit, she was less impressed by them. 'You have no idea the kind of bitches these people are,' she wrote in a letter to Nickolas Muray. 'They make me vomit. They are so damn "intellectual" and rotten that I can't stand them any more.' Wassily Kandinsky was a rare exception. He was a keen supporter of Frida's work, observing that it had a 'strong surrealist tone' and describing Frida as 'very charming'. Diego recalled that at the opening of Frida's exhibition, Kandinsky was 'so moved by Frida's paintings, that, right before everyone in the exhibition room, he lifted her into his arms, and kissed her cheeks and brow while tears of sheer emotion ran down his face.'

...

Kisses

From passionate love letters and gossip notes to friends, to long homesick missives to her family when she was away from her beloved Mexico, Frida's letters were full of affection, black humour and unstudied charm. She sent them with pressed flowers or brightly coloured feathers slipped between the pages, and almost always signed off with a pink or red lipstick kiss from her own lips.

Matilde Calderón was born in the Oaxaca region of Mexico. Frida embraced her mother's indigenous Mexican heritage and adopted traditional Tehuana dress as a symbol of her nationalism.

Matilde died in 1932 after suffering from breast cancer and gallstones, while Guillermo passed away in 1941.

After Frida was born, her mother became ill and was unable to nurse her, so Frida was taken care of by an indigenous wet nurse. Later, Frida came to regard this as an important part of her personal mythology, symbolising her connection with native Mexican culture.

In 1951, Frida painted a portrait of her father inscribed with the message: 'I painted my father, Wilhelm Kahlo, of German–Hungarian origin; a photographic artist by profession; generous, intelligent, and refined in character, and brave because he suffered from epilepsy for 60 years but never stopped working, and he fought against Hitler. Adoringly, his daughter, Frida Kahlo.'

As Frida was unable to bear children, she doted on her sister Cristina's children as if they were her own.

Frida looked like both her parents: 'I have my father's eyes and my mother's body.'

K
is for
THE KAHLO FAMILY

In 1891, Wilhelm Kahlo emigrated from Germany to Mexico, becoming a Mexican national and changing his name to Guillermo soon after he arrived. He married a Mexican woman named María Cardena in 1893 but, after having two daughters, she died in childbirth. Guillermo married Matilde Calderón y Gonzales soon after María's death. Matilde and Guillermo were very different people: he was of German–Hungarian descent, artistically inclined and an atheist, while she was Spanish–Indigenous Mexican, convent-raised, illiterate and deeply religious. But it was a mostly happy marriage that bore four daughters: Matilde, Adriana, Frida and Cristina. Frida was Guillermo's favourite daughter and he often used her as a model for his photographs – and she liked to spend time in his darkroom retouching plates and images. She was close to all her sisters but held a special affection for her younger sister, Cristina. When Diego had an affair with Cristina, Frida called it 'the greatest sadness' of her life – it took her a long time to forgive her sister, and even longer to forgive Diego. The sisters eventually mended their rift and Cristina remained one of the most important people in Frida's life.

L *is for* **LA CASA AZUL**

La Casa Azul, or the Blue House, was the place where Frida Kahlo was born and resided for most of her life. Located in Coyoacán on the corner of Londres and Allende streets, the structure was originally built by Guillermo Kahlo in the French colonial style. Economic hardship meant the family almost lost the house a number of times (and during lean years they sometimes took in paying guests), but after Frida and Diego were married, Diego paid off the mortgage so the family could continue living there. After Frida's parents passed away, she and Diego updated the house and its surrounds to reflect their love of Mexican culture: they painted the walls a clear, bright blue; swapped the prim European garden for a lush jungle of tropical plants; adopted a menagerie of animals; and built a pyramid of volcanic rock, which they decorated with pre-Columbian idols. Frida and Diego didn't reside in La Casa Azul for their whole marriage, sometimes living abroad, or in twin houses in San Ángel, or apart, but it was perhaps where they felt most at home. This may be why Frida elected to live at La Casa Azul when her health was failing – it was the place where she wanted to live out her final days.

The entrance of La Casa Azul was guarded by two giant papier-mâché Judas effigies, and the dining room showcased ancient pottery from Puebla, Jalisco and Michoacán. A collection of more than 400 retablos decorated the landing of the staircase leading to the study.

Frida y Diego vivieron en esta casa 1929-1954

TROTSKY
Su Moral
y la nuestra

When the Frida Kahlo Museum opened in July 1958, Frida's ashes were housed in a sack on her bed, along with a plaster death mask and her favourite *rebozo* (a type of shawl); later, her ashes were placed in a pre-Columbian jar in the shape of a rotund, headless woman. The death mask was cast in bronze and is now displayed beside the jar.

The house, now open to the public as the Frida Kahlo Museum, has been preserved exactly as Frida lived in it. It is full of her clothes, jewellery, toys, dolls, letters, books and art, vividly recalling the life she led and the things that were most important to her.

Overcome with grief after Frida's death, Diego locked her belongings in the bathroom of La Casa Azul and gave instructions that the room should remain sealed until 15 years after his death. In fact, the room remained undisturbed for more than 50 years. When it was finally opened in late 2003, over 6500 photographs, 22 documents and 300 garments belonging to Frida were discovered.

L

is also for

La Llorona
Also known as the Weeping Woman, La Llorona is a tragic figure from Tehuantepec folklore. Betrayed and abandoned by the man she loved, she murdered her children in her rage and grief and was condemned to wander the earth for eternity. The story touches on themes of love, infidelity and pain, so it's no wonder Frida saw herself reflected in the fable.

...

Jacqueline Lamba
While Frida had little patience for André Breton, she bonded with his second wife, Jacqueline Lamba. Like Frida, Jacqueline was a painter and, like Frida, she was overshadowed by her famous husband. 'The problem with El Señor Breton,' Frida once said, 'is that he takes himself so seriously.' Jacqueline, on the other hand, was as lively and charming as Frida. The two of them struck up a friendship that unfolded over visits between Mexico and France and numerous letters.

...

Julien Levy
A photographer, art dealer and gallery owner, Julien Levy was a keen supporter of Frida's work and arranged her first solo show in New York City. He was infatuated with her and the two may have had an affair – a series of photographs he took of Frida braiding her hair, wearing only her Tehuana skirts and with her chest bare like a Zapotec woman, certainly suggests an intimacy between them.

M

is also for

Nickolas Muray

One of Frida's more serious love affairs was with handsome Hungarian-born artist Nickolas Muray. They met in Mexico in 1931 and probably began to see each other clandestinely. The affair flourished in New York and their passion was recorded in the many letters that flew back and forth between them. 'Don't make love with anybody, if you can help it,' wrote Frida from Paris. 'Only if you find a real F.W. [fucking wonder] but *don't love her.*' Nickolas took countless photos of Frida, including luminous colour portraits, intimate black-and-white snaps, and startling documentation of her physical struggles.

...

Adolfo Best Maugard

Adolfo Best Maugard was an artist who had a profound influence on post-revolution Mexico. A contemporary of Diego Rivera, he wrote several groundbreaking books on pre-Columbian art and helped to implement new teaching methods in Mexico's schools. His ideas influenced a whole generation of Mexican artists – including Frida Kahlo.

...

Madonna

One huge admirer of Frida's work is a woman as iconic as Frida herself: Madonna. The queen of pop owns at least two of Frida's paintings – *Self-Portrait with Monkey* (1940) and *My Birth* (1932). 'If somebody doesn't like this painting,' Madonna told *Vanity Fair* in 1990 of the latter, 'then I know they can't be my friend.'

After the revolution, the country's mixed indigenous and Spanish colonial background became something to be celebrated as distinctly Mexican. Frida and Diego termed this identity 'Mexicanidad' – a sense of nationalism and pride in Mexican arts and culture, which looked toward a post-revolutionary, modern, visionary future.

'[M]y greatest desire for a long time has been to travel,' Frida wrote in a letter to Alejandro Gómez Arias in 1927 – but later, when she did travel, she found other countries alienating. She disliked the capitalism of America and the affected bohemianism of France, and missed Mexico deeply.

Frida's legacy is now an integral part of Mexican culture. After her death, Diego donated La Casa Azul and his own Anahuacalli Museum to the people of Mexico; they have become public museums to be enjoyed by all. Both Frida and Diego appeared on Mexico's 500-peso note from 2010 to 2018 – something that, as committed communists, they would probably find amusing.

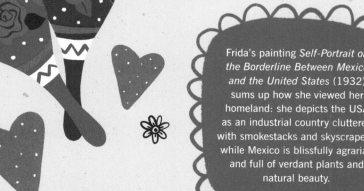

Frida's painting *Self-Portrait on the Borderline Between Mexico and the United States* (1932) sums up how she viewed her homeland: she depicts the USA as an industrial country cluttered with smokestacks and skyscrapers, while Mexico is blissfully agrarian and full of verdant plants and natural beauty.

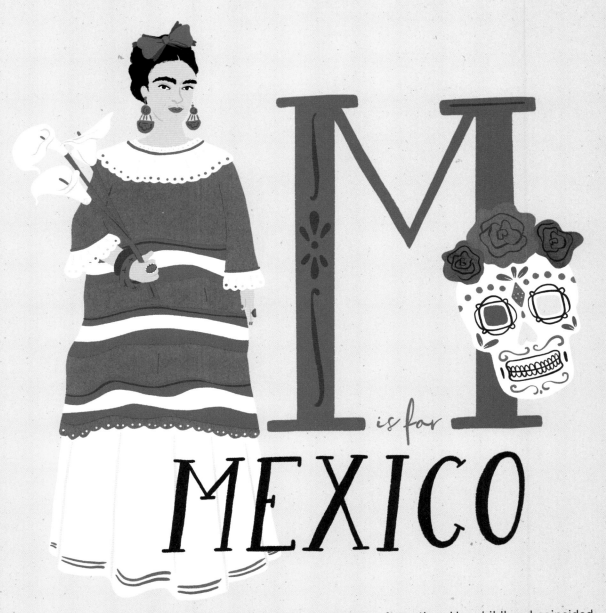

MEXICO

is for

During Frida Kahlo's formative years, Mexico was in a state of transformation. Her childhood coincided with the ten-year Mexican Revolution, which brought violence, instability and radical reform. When Frida painted *Four Inhabitants of Mexico* (1938), she depicted herself as a child in a desolate village square: 'empty, with few people,' she said, 'because too much revolution has left Mexico empty.' During Porfirio Díaz's three-decade dictatorship, the country had looked to European culture and attitudes for inspiration. Houses were built in elaborate neoclassical style, elegant restaurants served French cuisine and women followed the latest European fashions, while indigenous Mexican culture was despised. But by the early 1920s, after the inauguration of President Álvaro Obregón and the appointment of José Vasconcelos as minister of public education, the mood turned: Mexico would once again be built on 'our blood, our language, our people', as Vasconcelos put it. Frida embraced this sense of reformist zeal, and her love of indigenous Mexican culture informed every aspect of her art and life.

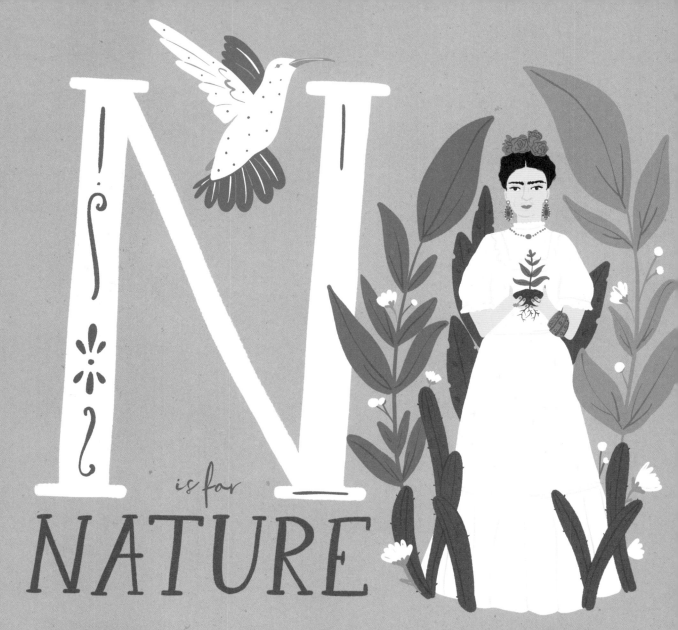

N is for NATURE

Frida and her plants were inseparable, both in life and in art. As a child, she and her father would gather plant specimens from parks in Coyoacán and take them home to sketch, dissect or peer at through Guillermo's microscope. Later, she filled the courtyard of La Casa Azul with plants and flowers native to Mexico: spiny cacti, prickly pears, yuccas, aloes, golden marigolds, bougainvillea, vibrant fuchsias, sunflowers, zinnias, dahlias. They adorned her table and her hair, and served as inspiration for her art. In many self-portraits, Frida depicted herself surrounded by nature – flowers, fruit, plants, birds, insects and animals – or even merging with nature. In 1944 she wrote in her diary of 'the vegetable miracle of my body's landscape', and she painted herself sprouting a vine in *Roots* (1943). In this painting she reclines on the earth dressed in her Tehuana garb while a verdant vine grows from within her chest. Her blood flows into the ground, forming roots that nourish the earth. As Hayden Herrera writes in her biography of Frida, 'Thus does Frida become a source of life rooted in the parched Mexican earth.'

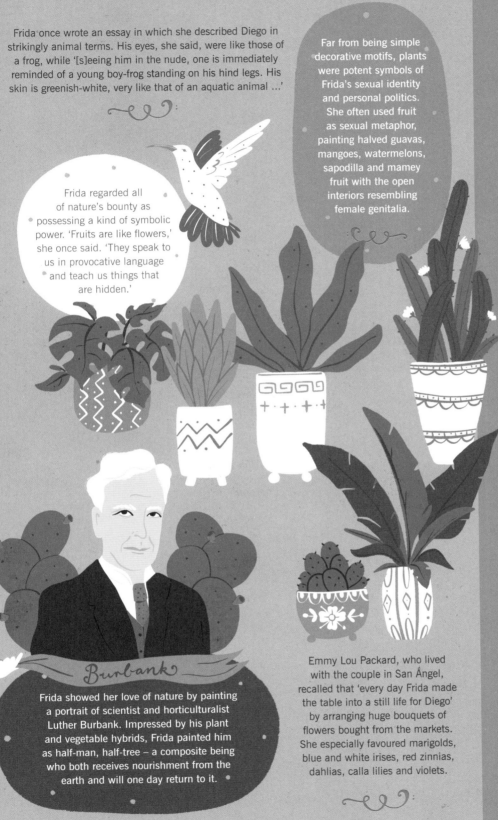

Frida once wrote an essay in which she described Diego in strikingly animal terms. His eyes, she said, were like those of a frog, while '[s]eeing him in the nude, one is immediately reminded of a young boy-frog standing on his hind legs. His skin is greenish-white, very like that of an aquatic animal …'

Far from being simple decorative motifs, plants were potent symbols of Frida's sexual identity and personal politics. She often used fruit as sexual metaphor, painting halved guavas, mangoes, watermelons, sapodilla and mamey fruit with the open interiors resembling female genitalia.

Frida regarded all of nature's bounty as possessing a kind of symbolic power. 'Fruits are like flowers,' she once said. 'They speak to us in provocative language and teach us things that are hidden.'

Burbank

Frida showed her love of nature by painting a portrait of scientist and horticulturalist Luther Burbank. Impressed by his plant and vegetable hybrids, Frida painted him as half-man, half-tree – a composite being who both receives nourishment from the earth and will one day return to it.

Emmy Lou Packard, who lived with the couple in San Ángel, recalled that 'every day Frida made the table into a still life for Diego' by arranging huge bouquets of flowers bought from the markets. She especially favoured marigolds, blue and white irises, red zinnias, dahlias, calla lilies and violets.

N *is also for*

New York
Frida and Diego went to New York in 1931 after Diego was invited to display a one-man retrospective at the Museum of Modern Art. He loved the city and the lavish world of New York society, but Frida found the experience distressing. 'High society here turns me off and I feel a bit of rage against all these rich guys here, since I have seen thousands of people in the most terrible misery without anything to eat and with no place to sleep,' she wrote in a letter. '[I]t is terrifying to see the rich having parties by day and night while thousands and thousands of people are dying of hunger …'

…

Isamu Noguchi
Renowned sculptor Isamu Noguchi was another of Frida's lovers. 'Since Diego was well known to be a lady chaser, she cannot be blamed if she saw some men,' Isamu once said. 'In those days, we all sort of, more or less, horsed around …'
Theirs was a short but passionate affair which ended, according to legend, when Diego discovered a sock Isamu had left behind in La Casa Azul and threatened to shoot his rival with a pistol.

…

Nudity
In spite of her discomfort with her body, Frida often depicted herself nude in her paintings – using nudity sometimes to evoke a sense of intimacy, sometimes to shock, sometimes matter-of-factly, sometimes with a sly wink. Her depiction of her nude body is never about the male gaze. She painted herself as she saw herself: broken, imperfect, vulnerable.

O is also for

Dolores Olmedo

Dolores Olmedo Patiño was 17 years old when she crossed paths with Diego. They met in an elevator at the Ministry of Public Education and formed a friendship that would last a lifetime. Dolores became a prominent art collector and acquired works by both Diego and Frida, even though she clashed with Frida. 'I did not get along with [her],' she told the *New York Times*. 'Well, she liked women, and I liked men, and I was not a Communist.' At Diego's request, Dolores was left in control of both artists' estates after Diego passed away in 1957.

...

Juan O'Gorman

Although La Casa Azul was their home for many years, Frida and Diego also lived for a time in a strikingly modern house in San Angel, designed by Juan O'Gorman. The residence was comprised of two separate houses linked by a rooftop bridge. Diego's side, painted pink, was large and grand, while Frida's was smaller, more private and painted blue. Later, in 1943, Juan also designed Anahuacalli, an ambitious studio–museum built to house Diego's pre-Columbian art collection.

...

Álvaro Obregón

In 1920, after a decade of violent revolution, Álvaro Obregón assumed the presidency in Mexico and brought with him economic, social and political reform. He established the Ministry of Public Education, instituted educational reforms aimed at enriching the lower classes, and had thousands of rural schools and public libraries built. Obregón helped usher in a new era in Mexico, in which Mexican identity was prized and art and culture flourished.

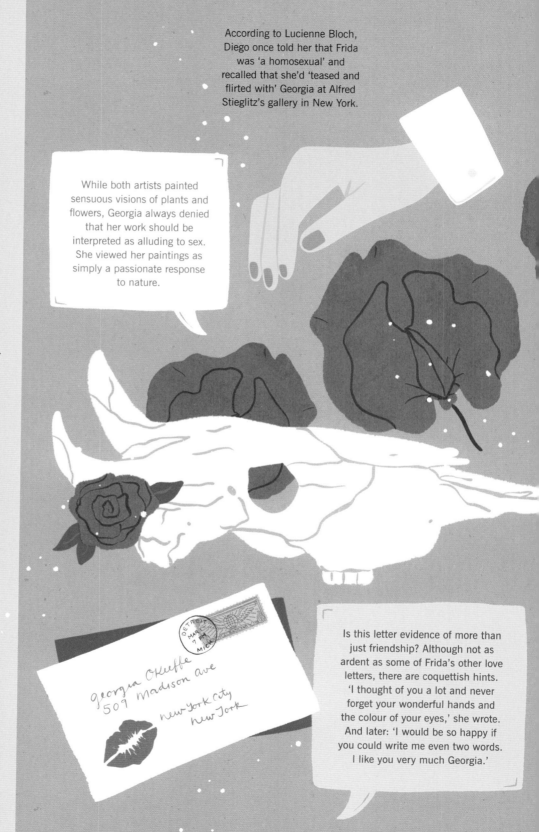

According to Lucienne Bloch, Diego once told her that Frida was 'a homosexual' and recalled that she'd 'teased and flirted with' Georgia at Alfred Stieglitz's gallery in New York.

While both artists painted sensuous visions of plants and flowers, Georgia always denied that her work should be interpreted as alluding to sex. She viewed her paintings as simply a passionate response to nature.

Is this letter evidence of more than just friendship? Although not as ardent as some of Frida's other love letters, there are coquettish hints. 'I thought of you a lot and never forget your wonderful hands and the colour of your eyes,' she wrote. And later: 'I would be so happy if you could write me even two words. I like you very much Georgia.'

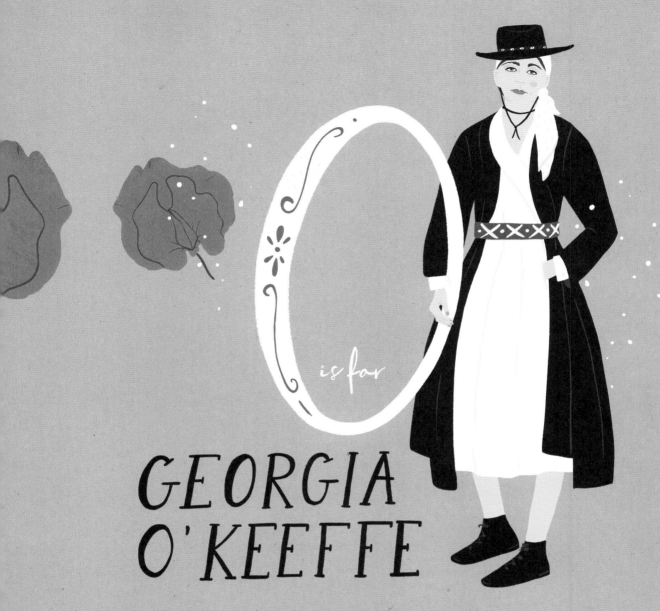

GEORGIA O'KEEFFE

Georgia O'Keeffe and Frida Kahlo were contemporaries and had much in common. Both were remarkable artists. Both had husbands whose careers were taken more seriously than their own. Both looked to nature to express sexuality and sensuality. Both struggled with their health – Frida with her myriad physical ailments, Georgia with depression. The two met in the early 1930s in New York, and in 1933, shortly after Georgia had been hospitalised for a nervous breakdown, Frida wrote her a heartfelt letter, in which she expressed her deep admiration of the artist: 'Every day since I called you and many times before months ago I wanted to write you a letter. I wrote you many, but every one seemed more stupid and empty and I torn them up.' Frida wrote of what she was doing in Detroit, of her work, of the difficulties she had experienced, and then ended her letter with: 'If you still in the hospital when I come back I will bring you flowers, but it is so difficult to find the ones I would like for you.'

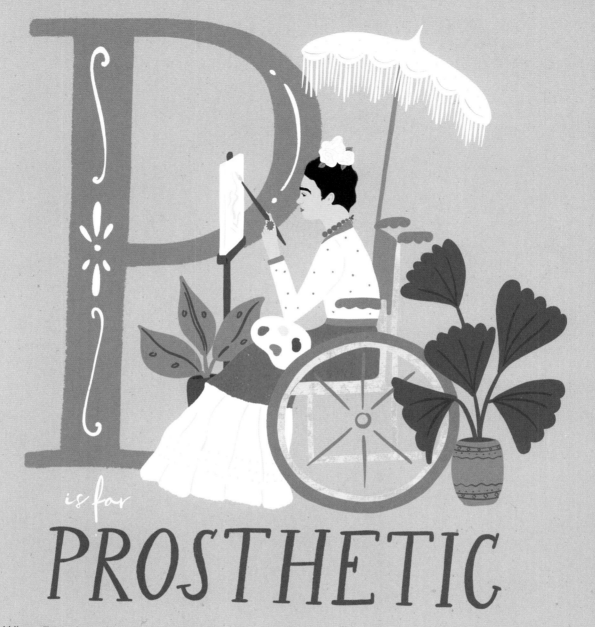

P is for PROSTHETIC

When Frida Kahlo's bathroom was opened more than 50 years after her death, one of the most arresting discoveries was her prosthetic leg, made from wood painted to match the colour of Frida's flesh, affixed with a leather brace at the top, which would have been laced around her thigh. The leg was completed by a dainty red leather boot with a wedge heel, a Chinese-style dragon embroidered on the vamp, and a pair of silver bells tied to the laces with a salmon-coloured ribbon so Frida would make music when she walked. She wore this prosthetic from 1953, when she had her leg amputated at the knee, until her death less than a year later. She hated it at first – it was only after she had the handsome leather boots made and the leg was rendered beautiful that she came around to wearing it. With the boots, Frida declared, she would 'dance her joy'.

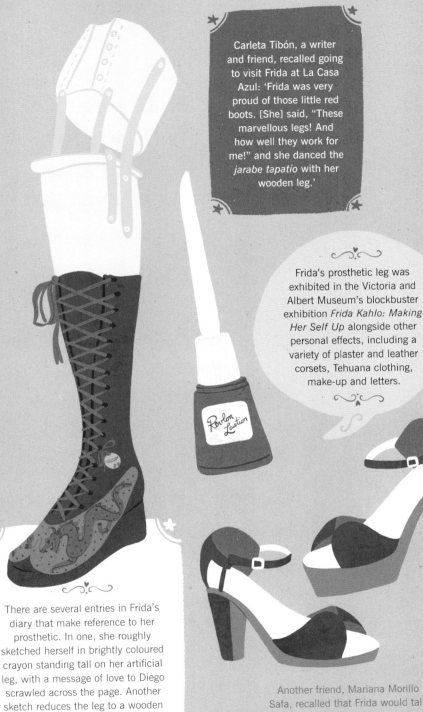

Frida's prosthetic leg was exhibited in the Victoria and Albert Museum's blockbuster exhibition *Frida Kahlo: Making Her Self Up* alongside other personal effects, including a variety of plaster and leather corsets, Tehuana clothing, make-up and letters.

Revlon Lastion

There are several entries in Frida's diary that make reference to her prosthetic. In one, she roughly sketched herself in brightly coloured crayon standing tall on her artificial leg, with a message of love to Diego scrawled across the page. Another sketch reduces the leg to a wooden stick (recalling a cruel childhood nickname 'Peg-leg Frida') while arrows point at all the places on her body where she has undergone surgery.

Another friend, Mariana Morillo Safa, recalled that Frida would talk about her prosthetic with a touch of black humour: 'At the time she was having a fight with her old friend Dolores del Río, and she joked, "I will send her my leg on a silver tray as an act of vengeance."'

P

is also for

Polio

Frida contracted polio when she was six years old. The disease caused the growth of her right leg to slow while her other leg continued to grow normally. To compensate for the difference, she would wear, on her thinner shorter leg, three or four socks and a shoe with a built-up heel to hide the asymmetry. Her stricken right leg deteriorated throughout her life, developing ulcers and tumours. She also developed gangrene, which required the amputation of two toes and then the leg below the knee.

…

Portraits

Although Frida is best known for her self-portraits, she frequently painted those around her too: friends and family, people she loved, figures she idolised. Diego featured prominently, as well as members of her family: she painted her sisters Adriana and Cristina very early in her career, and later immortalised her father. She often portrayed those for whom she harboured admiration, such as her doctors Leo Eloesser and Juan Farill, the botanist Luther Burbank, and political figures like Marx and Lenin.

…

Emmy Lou Packard

Diego once described Emmy Lou Packard as having 'the face of a French Gothic angel plucked from the reliefs of Chartres'. A talented artist who worked as his assistant and was later a muralist herself, Emmy Lou was a close friend of the couple and lived with them for almost a year in San Ángel. In her unpublished memoir, she recalled that Diego always seemed to be in awe of Frida, writing: 'He often said, "She is a better painter than I am."'

Q is also for

Queer icon
Frida's life was marked by intense relationships – most notably with Diego, but also with a whirl of other lovers, both men and women. Her rumoured same-sex lovers include Josephine Baker, Georgia O'Keeffe, Chavela Vargas, Teresa Proenza, Dolores del Río, Paulette Goddard and Maria Félix, some of whom were also involved with Diego. In fact, Diego encouraged Frida's queer affairs because he found them less threatening to his masculinity than her liaisons with other men.

...

Quinine
Frida desperately wanted to have a baby with Diego, but her health prevented her from carrying a pregnancy to term. Despite her Catholic upbringing, she had a pragmatic approach to abortion. 'Given the state of my health, I thought it would be better to abort,' she wrote to Dr Leo Eloesser from Detroit after consulting a local doctor about her condition. 'I told him so, and so he gave me a dose of "quinine" and a very strong purge of castor oil.'

...

Quechquemitl
Part of the traditional dress of indigenous Mexican women, a *quechquemitl* is a closed-shoulder cape that was often worn during rituals in the pre-Hispanic era, paired with a *huipil* and a long wraparound skirt. In keeping with her love of indigenous Mexican fashion, Frida frequently wore a *quechquemitl* sourced from Puebla, which was decorated with fertility symbols.

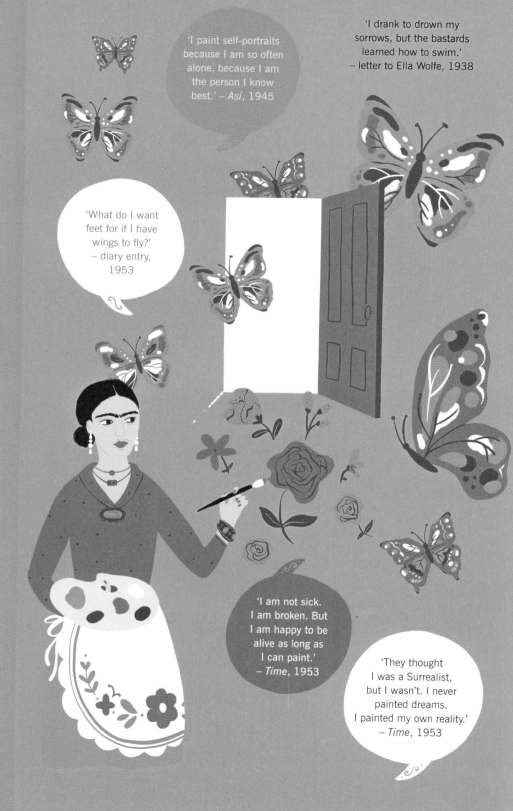

'I paint self-portraits because I am so often alone, because I am the person I know best.' – *Así*, 1945

'I drank to drown my sorrows, but the bastards learned how to swim.' – letter to Ella Wolfe, 1938

'What do I want feet for if I have wings to fly?' – diary entry, 1953

'I am not sick. I am broken. But I am happy to be alive as long as I can paint.' – *Time*, 1953

'They thought I was a Surrealist, but I wasn't. I never painted dreams. I painted my own reality.' – *Time*, 1953

QUOTES

is for

Poetic, honest, and possessing a darkly comic sense of humour, Frida Kahlo was never afraid to say exactly what was on her mind. She spoke Spanish and English and swore proficiently in both of them, taking great delight when those around her were shocked by her gutter vocabulary and sometimes trying to deliberately provoke with her sharp wit. When she and Diego were in Detroit, for example, she was seated at a dinner party next to industrialist and business magnate Henry Ford, who was a known anti-Semite. Affecting an air of innocence, Frida asked, 'Mr Ford, are you Jewish?' She spoke frankly in person and even more frankly in her letters and diaries, laying her heart bare on the page. Her writing reveals a woman who experienced everything deeply – she loved passionately, felt loss acutely and had opinions about almost everything. Frida always spoke as she painted: straight from her heart, giving voice to the extraordinary love and tragedy that marked her life.

RELATIONSHIPS

'I have suffered two grave accidents in my life,' Frida Kahlo once wrote. 'One in which a streetcar knocked me down … The other accident is Diego.' Diego María de la Concepción Juan Nepomuceno Estanislao de la Rivera y Barrientos Acosta y Rodríguez – better known as Diego Rivera – was born on 8 December 1886. He began drawing at a very young age, and was studying at night at the Academy of San Carlos in Mexico City by the time he was 12. Diego then won a scholarship to study full time at San Carlos under teachers including Félix Parra, Santiago Rebull and José María Velasco. He soon became one of Mexico's most famous artists. Diego was a man of great appetites: for women, for food, for fame, for politics, for his work. By the time Frida met him, he already had children by three women, two of them his wives. Diego was more than a foot taller than Frida, weighed three times as much as her, and was twice her age. It's perhaps no wonder that her family were nonplussed by their match, calling it the union of 'an elephant and a dove'.

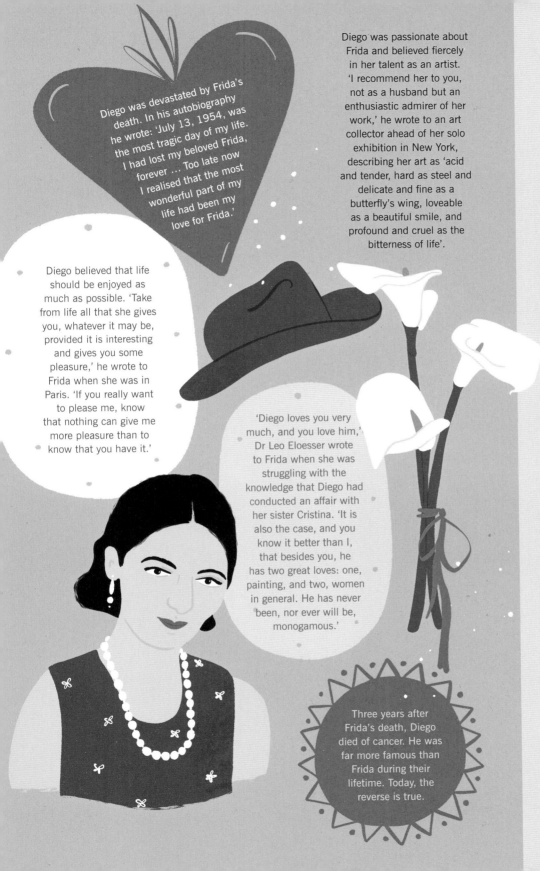

Diego was devastated by Frida's death. In his autobiography he wrote: 'July 13, 1954, was the most tragic day of my life. I had lost my beloved Frida, forever ... Too late now I realised that the most wonderful part of my life had been my love for Frida.'

Diego was passionate about Frida and believed fiercely in her talent as an artist. 'I recommend her to you, not as a husband but an enthusiastic admirer of her work,' he wrote to an art collector ahead of her solo exhibition in New York, describing her art as 'acid and tender, hard as steel and delicate and fine as a butterfly's wing, loveable as a beautiful smile, and profound and cruel as the bitterness of life'.

Diego believed that life should be enjoyed as much as possible. 'Take from life all that she gives you, whatever it may be, provided it is interesting and gives you some pleasure,' he wrote to Frida when she was in Paris. 'If you really want to please me, know that nothing can give me more pleasure than to know that you have it.'

'Diego loves you very much, and you love him,' Dr Leo Eloesser wrote to Frida when she was struggling with the knowledge that Diego had conducted an affair with her sister Cristina. 'It is also the case, and you know it better than I, that besides you, he has two great loves: one, painting, and two, women in general. He has never been, nor ever will be, monogamous.'

Three years after Frida's death, Diego died of cancer. He was far more famous than Frida during their lifetime. Today, the reverse is true.

R is also for

Rebozo
Frida was seldom seen without her *rebozo*, a large shawl that she wore draped around her shoulders and a traditional part of colonial Mexican dress. In some parts of Mexico, a man gives the woman he wishes to marry a *rebozo* rather than a wedding ring, so Frida's *rebozo* was likely a symbol of her devotion not only to Mexican culture but to Diego himself.

...

Edward G. Robinson
Edward G. Robinson was an actor best known for playing gangsters and tough guys. He was also a passionate art collector. In the 1930s, he travelled to Mexico City and visited Diego in his studio, where he came across Frida's work. He bought four paintings from her for $200 each, becoming one of her very first buyers.

...

Resplandor
A *resplandor* is a starched lace headdress typically worn by women of the Isthmus of Tehuantepec region in southern Mexico for festive occasions like weddings, saints' days and processions. Frida owned at least two *resplandor* and painted herself in the dramatic headdress twice.

...

Revlon
Frida's preferred brand of make-up was Revlon: she wore blush in 'Clear Red' and a ruby lipstick in 'Everything's Rosy', and painted her nails in 'Raven Red', 'Frosted Pink Lightning' and 'Frosted Snow Pink'. And her famous unibrow? Enhanced by a Revlon brow pencil in the shade 'Ebony'.

S is also for

San Francisco

Frida and Diego travelled to San Francisco in 1930. While Diego worked on his murals, Frida explored the city on her own. She didn't take to the US straight away. 'I don't particularly like the *gringo* people,' she wrote in a letter. 'They are boring and they all have faces like unbaked rolls.' In contrast, the people of San Francisco were captivated by her. 'She causes much excitement on the streets of San Francisco,' recalled photographer Edward Weston. 'People stop in their tracks to look in wonder.'

...

Still life

In 1952, Frida started producing still life paintings. Her favourite subjects were fruit and flowers (as well as dolls, insects and animals), rendered in vibrant colours and careful brushstrokes. Sometimes she added political iconography or created visual double meanings: cut fruit recalls female genitalia, and fleshy plants exploding with stamens allude to sex and fertility. 'Frida Kahlo de Rivera's paintings looking like D.H. Lawrence on canvas,' wrote *Vogue* magazine in 1938, 'all fertility and gore.'

...

Shocking

Frida's signature scent was 'Shocking' by Elsa Schiaparelli, a perfume that lived up to its name: it was deemed scandalous on its release because its bottle resembled the hourglass shape of a woman. The perfume was comprised of fragrant top notes of jasmine and honey over a spicy base of cloves and civet – friends recalled that if they smelled honey and cloves, they knew Frida was near.

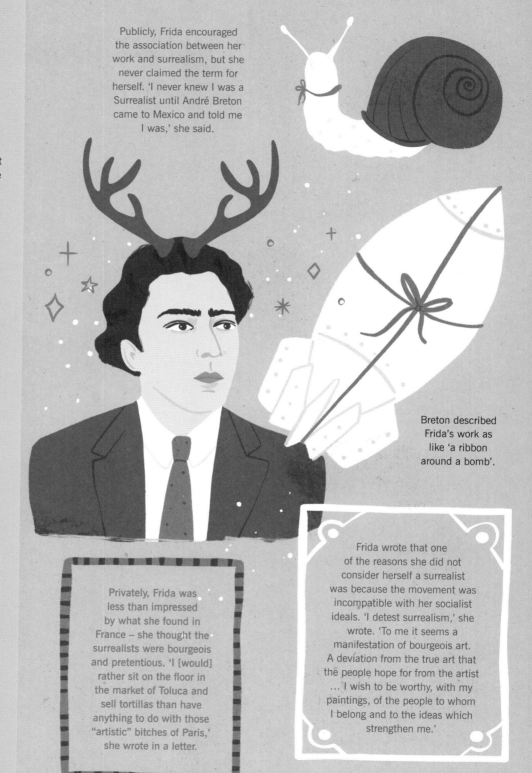

Publicly, Frida encouraged the association between her work and surrealism, but she never claimed the term for herself. 'I never knew I was a Surrealist until André Breton came to Mexico and told me I was,' she said.

Breton described Frida's work as like 'a ribbon around a bomb'.

Privately, Frida was less than impressed by what she found in France – she thought the surrealists were bourgeois and pretentious. 'I [would] rather sit on the floor in the market of Toluca and sell tortillas than have anything to do with those "artistic" bitches of Paris,' she wrote in a letter.

Frida wrote that one of the reasons she did not consider herself a surrealist was because the movement was incompatible with her socialist ideals. 'I detest surrealism,' she wrote. 'To me it seems a manifestation of bourgeois art. A deviation from the true art that the people hope for from the artist ... I wish to be worthy, with my paintings, of the people to whom I belong and to the ideas which strengthen me.'

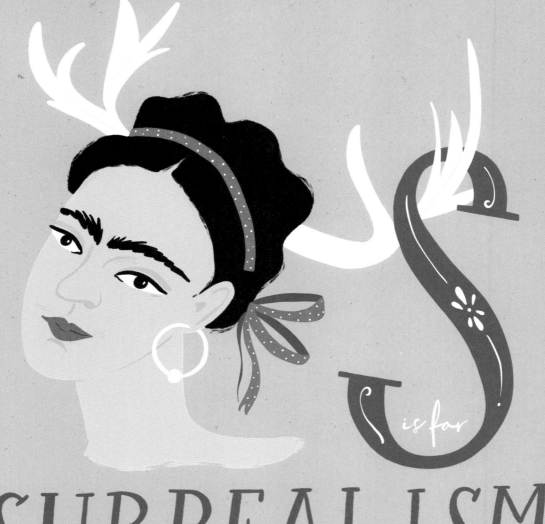

SURREALISM

S is for

In 1938 André Breton came to Mexico, a country he would later call 'the Surrealist environment par excellence'. The French surrealist was captivated by what he saw as Mexico's 'exotic' culture and equally captivated by Frida Kahlo – he declared her work had a 'pure surreality' and immediately claimed her as a kind of naive surrealist whose work spontaneously and independently reflected the French movement's ideas and preoccupations. Surrealism was the height of fashion at the time, and its devotees in Paris took it very seriously. Not so Frida. 'I use Surrealism as a way of poking fun at others without their realising it, and of making friends with those who do not realise it,' she said. While Frida's work had some commonalities with surrealism, such as the use of symbolic associations and her focus on the female body, she was less concerned with the subconscious world of dreams and the irrational, which so fuelled the surrealists. While the startling imagery in her work sometimes looked like a surrealistic dream, in fact she was concerned with depicting the extraordinary circumstances of her life.

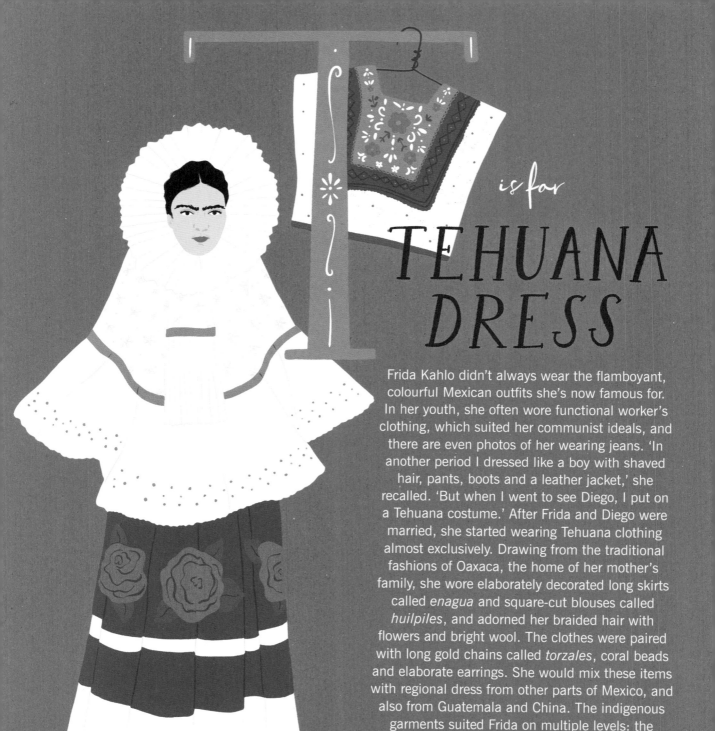

is for TEHUANA DRESS

Frida Kahlo didn't always wear the flamboyant, colourful Mexican outfits she's now famous for. In her youth, she often wore functional worker's clothing, which suited her communist ideals, and there are even photos of her wearing jeans. 'In another period I dressed like a boy with shaved hair, pants, boots and a leather jacket,' she recalled. 'But when I went to see Diego, I put on a Tehuana costume.' After Frida and Diego were married, she started wearing Tehuana clothing almost exclusively. Drawing from the traditional fashions of Oaxaca, the home of her mother's family, she wore elaborately decorated long skirts called *enagua* and square-cut blouses called *huilpiles*, and adorned her braided hair with flowers and bright wool. The clothes were paired with long gold chains called *torzales*, coral beads and elaborate earrings. She would mix these items with regional dress from other parts of Mexico, and also from Guatemala and China. The indigenous garments suited Frida on multiple levels: the long skirts and blouses disguised her physical impairments and the corsets she had to wear, and also served as emblems of her national pride. Tehuantepec women were renowned in Mexico for their beauty, bravery, strength and intelligence — qualities that definitely describe Frida.

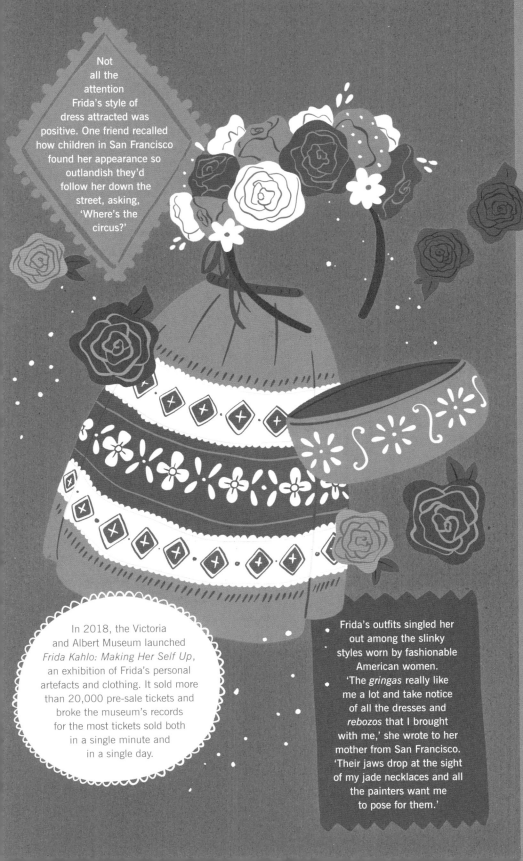

Not all the attention Frida's style of dress attracted was positive. One friend recalled how children in San Francisco found her appearance so outlandish they'd follow her down the street, asking, 'Where's the circus?'

In 2018, the Victoria and Albert Museum launched *Frida Kahlo: Making Her Self Up*, an exhibition of Frida's personal artefacts and clothing. It sold more than 20,000 pre-sale tickets and broke the museum's records for the most tickets sold both in a single minute and in a single day.

Frida's outfits singled her out among the slinky styles worn by fashionable American women. 'The *gringas* really like me a lot and take notice of all the dresses and *rebozos* that I brought with me,' she wrote to her mother from San Francisco. 'Their jaws drop at the sight of my jade necklaces and all the painters want me to pose for them.'

T is also for

Leon Trotsky

In the 1930s Diego and Frida petitioned Mexico's leftist president Lázaro Cárdenas to grant political asylum to the Marxist revolutionary Leon Trotsky. Trotsky and his wife were installed in La Casa Azul as guests, and the Russian immediately fell for Frida. The two began a clandestine affair and Frida commemorated her admiration by painting a self-portrait dedicated to him. The affair ended, but when Trotsky was assassinated some years later by a pro-Stalinist agent, Frida was considered a suspect. She was held by the police and interrogated for 12 hours.

...

Raquel Tibol

Raquel Tibol arrived in Mexico in 1953 to help Diego with an exhibition he was launching, but was immediately drawn into helping care for Frida. 'She was obsessed with being surrounded by things,' Raquel recalled in a BBC interview. 'In her room, she had a wardrobe with a see-through door full of toys and bits of popular art. Everything was in its place – so tidy. Though she was physically a wreck, everything about her was tidy and she was always so well turned out.' Raquel went on to become a prominent art critic and historian, and wrote several books on Frida's life and art.

...

Spencer Tunick

In 2007, photographer Spencer Tunick – famous for organising mass nude photoshoots in public spaces – photographed 105 naked women among the verdant foliage in the courtyard of La Casa Azul. With their hair braided like Frida's, the women paid striking tribute both to Frida's vulnerability and to her defiant spirit.

U

is also for

Unsolved mystery

In 1940, Frida painted a piece called *The Wounded Table*. It was her largest-ever painting and depicted her seated at a table surrounded by a surreal selection of guests: a smiling skeleton, a pre-Columbian clay figure, a huge Judas effigy with a passing resemblance to Diego Rivera, her niece and nephew, and even her pet deer, Granizo. First shown at the International Surrealism Exhibition in Mexico City in 1940, *The Wounded Table* was exhibited only a handful of times before it disappeared in 1955 while en route from Warsaw to be shown in an exhibition in Moscow. Three photos taken between 1940 and 1944 are known to document the painting, and despite decades of searching, it has never been found.

...

United States of America

Early in their marriage, Frida and Diego spent time in San Francisco, Detroit and New York. While Diego loved the USA, Frida was ambivalent about it – she found the society alienating and missed Mexico deeply. This may have been part of the reason why she began to wear her distinctive Tehuana look full-time, assembling a wardrobe of dresses and accessories and adopting a style that asserted her national pride and marked her as the most Mexican of Mexicans. But there were some aspects of American culture she loved: she developed a taste for malted milk, applesauce and American cheese, adored going to the cinema (her favourite movie was *Tarzan),* and spent time in Harlem soaking up the thriving jazz culture.

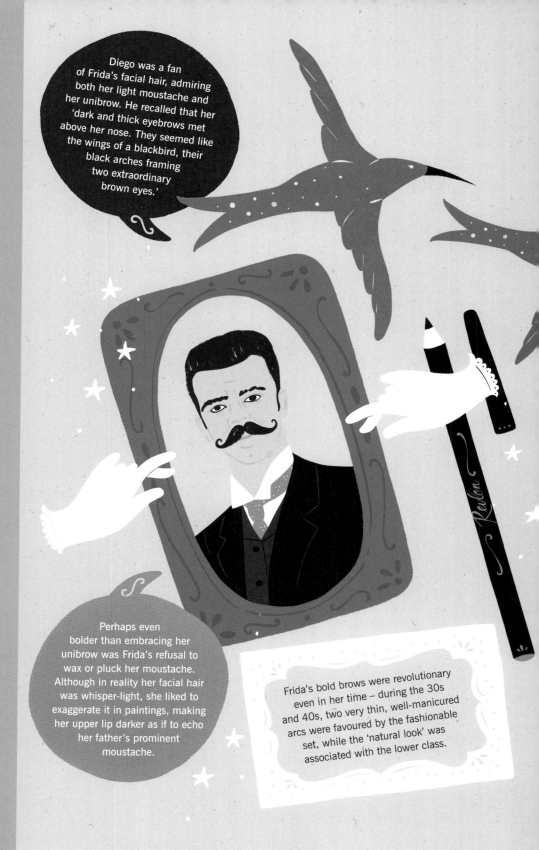

Diego was a fan of Frida's facial hair, admiring both her light moustache and her unibrow. He recalled that her 'dark and thick eyebrows met above her nose. They seemed like the wings of a blackbird, their black arches framing two extraordinary brown eyes.'

Perhaps even bolder than embracing her unibrow was Frida's refusal to wax or pluck her moustache. Although in reality her facial hair was whisper-light, she liked to exaggerate it in paintings, making her upper lip darker as if to echo her father's prominent moustache.

Frida's bold brows were revolutionary even in her time – during the 30s and 40s, two very thin, well-manicured arcs were favoured by the fashionable set, while the 'natural look' was associated with the lower class.

U is for UNIBROW

Of all her features, Frida Kahlo's eyebrows are undoubtedly her most famous. Thick, black and meeting gently in the middle, her unibrow was immortalised in her self-portraits, where she often painted it as more pronounced than it was in life. 'Her light-tan face was not pretty, perhaps, by established norms but she possessed – and even radiated – a strange and alluring beauty,' wrote Olga Campos, a psychology student and friend. 'She had a special skill for applying make-up and achieving a natural look, and spent a lot of time on this effect ... She knew how to transform herself into a sensational beauty, irresistible and unique.' Part of Frida's charm was to enhance her brows with the help of a Revlon brow pencil, shading the space between so that they met more distinctly in the middle. She also used a French product called Talika, which encouraged hair growth, meaning she actively encouraged her unibrow to grow ever more resplendent.

is for

V

VIVA LA VIDA

A month before she died, Frida Kahlo completed her final painting: a small, vibrantly coloured still life of watermelons set against a brilliant blue background. The ripe, juicy slices evoke the fullness of life and Frida's sense of _alegría_ – her joy, her passion, her belief that life should be lived to the fullest. 'Nothing is worth more than _laughter_,' she wrote in her diary. 'It is strength to laugh and to abandon oneself, to be light. _Tragedy_ is the most ridiculous thing.' But in keeping with the tradition of still life paintings as _vanitas_, the fruit also represents impermanence: the watermelons, cut and sliced, evoke the transience of life and the certainty of death. Eight days before she died, Frida put her final touch on the painting, signing her name and inscribing the largest, most bountiful watermelon piece with a phrase that perfectly summed up her approach to life:
Viva la vida. Long live life.

Even when she was dying, Frida approached life with a flair for spectacle. For the opening of her final exhibition, when she was too ill to stand, she was carried into the gallery on a hospital stretcher and delivered to her four-poster bed, which had been installed especially for the occasion; she then presided over the evening like a queen from her throne.

Frida's work often dealt with painful subject matter – the pain of her body, her miscarriages and abortions, her heartbreak over Diego – but she never portrayed self-pity. She did not endure her life: she transfigured it into art that reflected her strength and indomitable spirit.

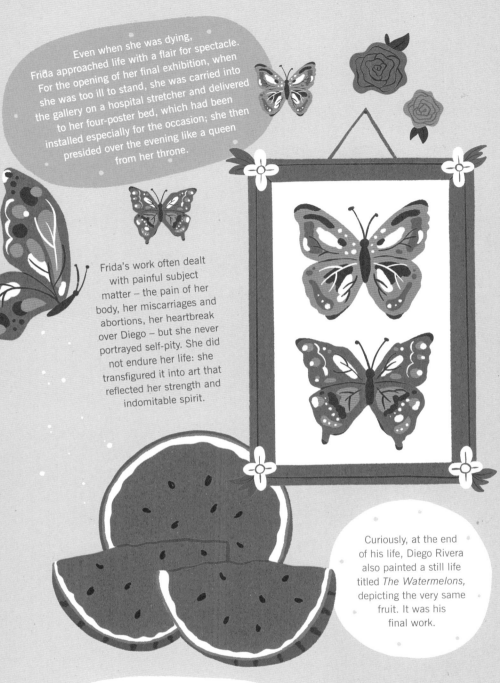

Curiously, at the end of his life, Diego Rivera also painted a still life titled *The Watermelons*, depicting the very same fruit. It was his final work.

Although she lived her whole life in chronic pain, Frida came to see pain as a necessary part of existence. Her will to live was legendary and one of her lovers described her as 'a wild and passionate person'. She summed up her ethos in her diary: 'Anguish and pain, pleasure and death are nothing but a process in order to exist.'

'Her being was made [of] love for life,' wrote Juan O'Gorman in an essay after Frida's death. 'Love for art, love for *la materia*, love for Mexico, love for Diego, love for her family, love for the stones, love for the plants, love for people – and she converted it all to painting.'

V
is also for

Chavela Vargas
In the 1950s, Chavela Vargas was a sensation – a lesbian who smoked cigars, carried a gun, downed tequila and wore men's clothing. She sang passionate *rancheras*, Mexican folk songs traditionally sung by male singers about women they have loved and lost. Chavela stayed with Frida and Diego at La Casa Azul and it's rumoured she and Frida had an affair. 'I learned … secrets I shall never reveal,' she once said. 'We … lived day to day, without a cent, sometimes with nothing to eat, but dying of laughter.'

…

Voice
What did Frida sound like? Those who knew her said her voice was deep and a little hoarse, 'melodious and warm', punctuated by *carcajadas* (belly laughs). In 2019, the National Sound Library of Mexico unearthed what it believed could be the only known voice recording of Frida, taken from a 1954 radio show. But others, including members of the Kahlo family, have disputed the claim, saying it isn't how they remember Frida sounding.

…

José Vasconcelos
A noted lawyer and philosopher, José Vasconcelos was appointed minister of public education after the Mexican Revolution finally came to an end. He embarked on a mission to bring literacy and art to the people through the creation of new libraries, open-air art schools and public murals. In 1921 he commissioned Diego Rivera to paint a mural at the Escuela Nacional Preparatoria – which led Diego into the path of Frida Kahlo.

W *is also for*

The Wounded Deer

In 1946, while in New York, Frida underwent surgery on her spine. 'They took out a piece of my pelvis to graft it onto the backbone,' she wrote in a letter, adding that she'd been left with two huge scars on her shoulderblades.

She commemorated the experience by painting *The Wounded Deer*, a strikingly surreal painting in which Frida appears with the body of a young stag, surrounded by dark, verdant forest. Like the Catholic martyr Saint Sebastian, she is pierced with arrows, yet her face remains calm. The painting expresses Frida's lifelong struggle with pain but also speaks to her longing for oneness with nature. In her personal mythology, nature represented life, fertility and connection – all the things she wanted for herself.

...

Weddings

Frida was married twice in her life, both times to Diego. Their first wedding took place on 21 August 1929 in a civil ceremony at Coyoacán's city hall. Frida wore simple street clothes and a *rebozo* while Diego wore an American-style suit. Afterwards, there was a big party where Diego got drunk, threatened someone with a pistol and broke a man's finger. Their second wedding, in 1940 – less than a year after their divorce – took place in San Francisco. Frida wore a Spanish costume with a long green and white skirt and a brown shawl. This time there was no reception or party: instead, Diego went straight back to work on the mural he was painting.

Other patronising articles were written about Frida's art. 'Little Frida's pictures, mostly painted in oil on copper, had the daintiness of miniatures, the vivid reds and yellows of Mexican tradition and the playfully bloody fancy of an unsentimental child,' wrote a *Time* magazine critic after her show in New York in 1938.

In Paris, Frida's reviews were more favourable. After her *Mexique* show in 1939, curated by André Breton, a critic for *La Flèche* praised the sincerity of her work and noted that in a period when 'guile and swindle are in style, the striking probity and exactitude of Frida Kahlo de Rivera spare us many strokes of genius'.

NEW YORK

PARIS

Frida swung between doubting her talent as a painter and being supremely self-confident. In 1932, long before she was famous, a journalist asked if she was a painter like her husband. 'Yes,' she replied, 'the greatest in the world.' Privately, she suffered from self-doubt, once describing her work as 'small and unimportant' and worrying that the personal subject matter she returned to again and again wouldn't be interesting to anyone but herself.

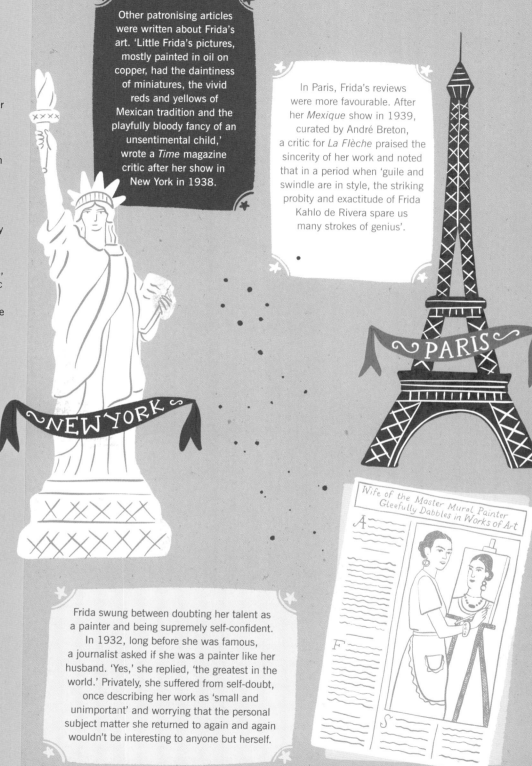

Wife of the Master Mural Painter Gleefully Dabbles in Works of Art

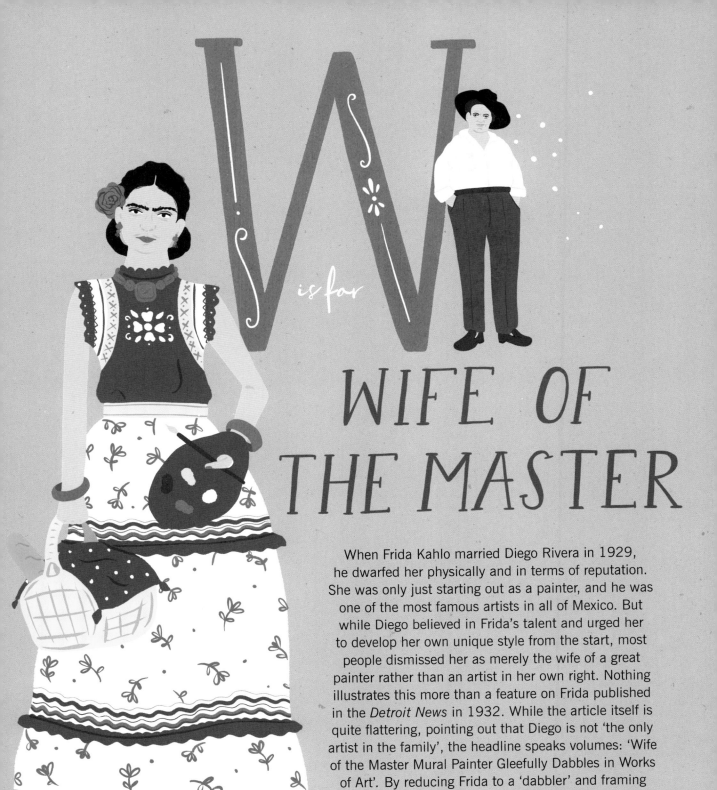

W is for WIFE OF THE MASTER

When Frida Kahlo married Diego Rivera in 1929, he dwarfed her physically and in terms of reputation. She was only just starting out as a painter, and he was one of the most famous artists in all of Mexico. But while Diego believed in Frida's talent and urged her to develop her own unique style from the start, most people dismissed her as merely the wife of a great painter rather than an artist in her own right. Nothing illustrates this more than a feature on Frida published in the *Detroit News* in 1932. While the article itself is quite flattering, pointing out that Diego is not 'the only artist in the family', the headline speaks volumes: 'Wife of the Master Mural Painter Gleefully Dabbles in Works of Art'. By reducing Frida to a 'dabbler' and framing her as only of interest because of her relationship to her famous husband, the article perfectly captures how hard it was for Frida to be taken seriously.

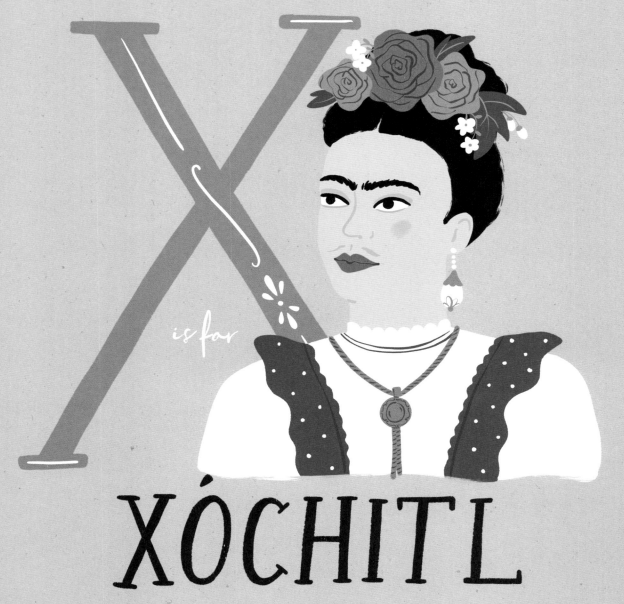

X is for XÓCHITL

Frida Kahlo wrote hundreds of letters over the course of her life, leaving a rich legacy of personal correspondence with friends, lovers and family. Her letters reveal the many sides of her personality. To her parents she was 'Friducha' or 'little Frida', the loving daughter who wrote to ask for neighbourhood gossip from Coyoacán when she was lonely abroad. In devoted love letters to Diego, she was 'your girl, Frida'. To her friend Ella Wolfe, she was 'the popular and powerful Chicua'. To other friends, such as Lucienne Bloch, she was 'chiquita' or 'chicuita', meaning 'tiny one' or 'petite one'. To her lover José Bartoli, she signed off as 'Mara', short for 'Maravillosa', meaning 'marvellous' – José's pet name for her. And to Nickolas Muray, she was 'Xóchitl', meaning 'flower' or 'delicate thing' in the Nahuatl language.

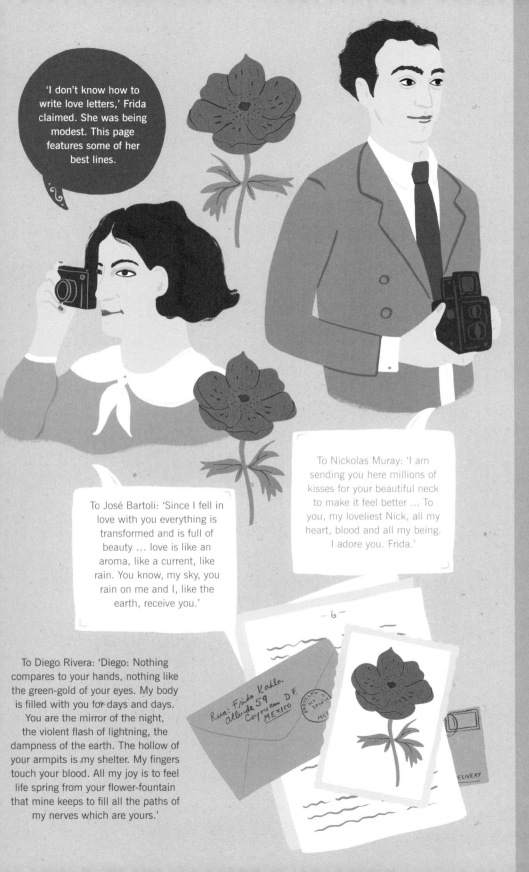

'I don't know how to write love letters,' Frida claimed. She was being modest. This page features some of her best lines.

To Nickolas Muray: 'I am sending you here millions of kisses for your beautiful neck to make it feel better … To you, my loveliest Nick, all my heart, blood and all my being. I adore you. Frida.'

To José Bartoli: 'Since I fell in love with you everything is transformed and is full of beauty … love is like an aroma, like a current, like rain. You know, my sky, you rain on me and I, like the earth, receive you.'

To Diego Rivera: 'Diego: Nothing compares to your hands, nothing like the green-gold of your eyes. My body is filled with you for days and days. You are the mirror of the night, the violent flash of lightning, the dampness of the earth. The hollow of your armpits is my shelter. My fingers touch your blood. All my joy is to feel life spring from your flower-fountain that mine keeps to fill all the paths of my nerves which are yours.'

Rvr: Frida Kahlo.
Allende 59
Coyoacan D.F.
MEXICO

X
is also for

X-rated
Frida may have lived in a conservative era, but, for her time, she was frank and open about sex. She wrote steamy letters to her many lovers ('Last night I felt as if many wings caressed me all over, as if your finger tips had mouths that kissed my skin,' she wrote to José Bartoli) and depicted her sexuality in paintings with palpable erotic energy. Even her paintings of plants are racy – her *Flower of Life* (1943), which depicts two species of flower fused together to resemble a red, engorged phallus with labia-like petals, was deemed too explicit for the general public and had to be shown in a separate room when it was first exhibited.

…

Señor Xolotl
Of all her pets, Frida's Xoloitzcuintli dogs were her favourites. Chief among them was one called Señor Xolotl, named after the Aztec god of fire and lightning (as well, tellingly, of misfortune, sickness and deformities). The hairless pup made an appearance in several paintings, including one of her most famous, *The Love Embrace of the Universe, the Earth (Mexico), Diego, Me, and Señor Xólotl* (1949).

…

X-ray
Frida's accident left her spine permanently damaged, and over the course of her life she had countless X-rays. The procedure became so familiar to her that she began to depict her body as transparent in self-portraits – her exposed spine in *The Broken Column* (1944) was almost certainly influenced by her having seen radiographs that exposed the interior of her own body.

Y

is also for

Yin and yang

In 1947, Diego completed a mural called *Dream of a Sunday Afternoon in Alameda Park* at the Hotel de Prado in Mexico City. He included in it a portrait of Frida wearing her signature *rebozo* and braided hair, holding in her hand a yin and yang (taijitu) symbol. A powerful image of duality, the yin and yang sums up Frida's worldview. Diego's daughter Guadalupe Rivera Marin recalled that Frida read a lot of Chinese philosophy and saw the symbol as 'the eternal, the cosmos seen through perpetual movement'. Frida sometimes wore a silver necklace by Matilde Poulat that featured a yin and yang held up by two birds, and sometimes doodled the symbol in her diary. Guadalupe observed it was 'the symbol of Frida's life'.

...

Yucca

Native to Mexico, the USA and parts of South America, the yucca was loved by Frida. She filled the courtyard of La Casa Azul with the spiny plants, and in 1937 *Vogue* published a now-iconic photograph of Frida for a feature called 'Señoras of Mexico' that showed her standing beneath a giant yucca plant wearing a sky-blue ruffled blouse and a white *enagua*, holding her favourite plum-coloured *rebozo* aloft over her head.

Yellow features in many of Frida's paintings to striking effect. In *Self-Portrait with Small Monkey* (1945), a yellow ribbon is wrapped around her neck – from 1940 onwards, in self-portraits she began to encircle her neck with ribbons, veins, vines or a monkey's long arms, which threaten to choke her.

In Aztec mythology, the *cempasúchil* (Mexican marigold) was known as the flower of the dead. Frida painted the yellow and orange blooms in paintings such as *The Deceased Dimas* (1937) and *Girl with Death Mask* (1938).

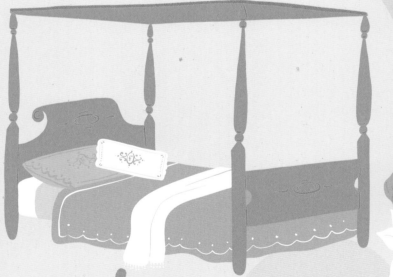

Yellow roses feature in one of Frida's most controversial paintings: they are pinned to the black velvet dress worn by Dorothy Hale in *The Suicide of Dorothy Hale* (1938).

The yellow bedspread in *The Dream* (1940) is hallucinatory, coupled with a skeletal Judas figure and vines that grow from Frida's bed, while *The Deceased Dimas* (1937) portrays the death of a little boy who is clothed in yellow robes.

One of the most fascinating things about Frida Kahlo's work is its symbolism, which she developed over the years to function as a private, personal language. Along with a vocabulary of imagery, she used specific colours to convey what she was thinking and feeling: green meant 'good, warm light', magenta reminded her of the 'old blood of the prickly pear', navy blue evoked 'distance' but she also said 'tenderness can be this blue'. In Frida's eyes, yellow was often a negative colour, reminding her of 'madness, sickness, fear'. She wrote that 'all the ghosts wear clothes of this colour, or at least their underclothes', although she conceded that yellow could also be 'part of the sun and of joy'.

is for

YELLOW

ZAPOTEC

Zapotec women from the Isthmus of Tehuantepec in Oaxaca were an enduring inspiration to Frida Kahlo. They were famous for their sense of self-possession and were known for being independent, at ease with their bodies and financially liberated from men. Zapotec culture was a rare matriarchal society where the women ran the markets (they sold everything from textiles to fresh produce, folk art and even iguanas – all of it carried to the markets on their heads), handled fiscal matters and generally lorded over the men. In Frida's day, it was fashionable for modern, city-dwelling bohemian women to adopt the clothing of indigenous Mexicans as a way of declaring their solidarity with post-revolution Mexico and pride in their culture away from outside influence. 'The classic Mexican dress has been created by the people for the people,' said Diego. 'The Mexican women who do not wear it do not belong to the people, but are mentally and emotionally dependent on a foreign class to which they wish they belong, i.e., the great American and French bureaucracy.'

While Frida looked to Zapotec women for sartorial inspiration, her approach to dressing was defiantly avant-garde. She liked to mix and match items from different regions across Mexico, as well as the occasional piece sourced from her travels to the United States and France.

Frida was drawn to the Oaxaca region's history, architecture, clothing and art. The influence of ancient architecture such as the Monte Albán pyramids, once home to the Zapotecs, can be seen in the pyramid in La Casa Azul's courtyard.

ISTMO DE TEHUANTEPEC

To Frida, the Zapotec women were symbols of economic independence and power, which aligned with her sense of being an outsider – faithful to tradition but at the same time embracing a modern, liberated lifestyle.

Many of Frida's contemporaries, like Rosa Covarrubias and Dolores Olmedo, looked to Zapotec women for inspiration. Even Natalia Chacón, wife of President Plutarco Elías Calles, was photographed in Tehuana dress for an official portrait.

Z
is also for

Emiliano Zapata

Emiliano Zapata was one of the most important figures of the Mexican Revolution. Calling for 'reform, freedom, justice and law', he led an army of peasants and indigenous Mexicans against the central Mexican government in a brutal ten-year revolution that left the country's population decimated. In her diary, Frida wrote that when she was a child, 'I saw with my own eyes the clash between Zapata's peasants and the forces of [President Venustiano] Carranza,' adding that the 'clear and precise emotions of the Mexican Revolution' shaped her political views.

...

Adelina Zendejas

A member of the Los Cachuchas clique, Adelina Zendejas was one of Frida's close friends when they were teenagers. She recalled how stoic Frida was after her accident, saying, 'When we went to visit her when she was sick, she played, she laughed, she commented, she made caustic criticisms, witticisms and wise opinions. If she cried, no one knew it.' Like Frida, Adelina went on to be a communist and feminist, and the two maintained their friendship until Frida's death in 1954. At Frida's funeral, Adelina emphasised the qualities she'd observed in Frida when she was a girl at the Escuela Nacional Preparatoria: her verve, her passion and her 'iron will to live'.

Smith Street Books

Published in 2020 by Smith Street Books
Naarm | Melbourne | Australia
smithstreetbooks.com

ISBN: 978-1-925811-47-6

Publisher: Paul McNally
Project editor: Hannah Koelmeyer
Editor: Katie Purvis
Design: Michelle Mackintosh
Illustration: Susanna Harrison, The Illustration Room
Proofreader: Ariana Klepac

Printed & bound in China by C&C Offset Printing Co., Ltd.

Book 125

10 9 8 7 6 5 4 3 2 1

Frida Kahlo brand © 2020 Frida Kahlo Corporation.
www.fridakahlocorporation.com

Product licensed in Australia in association with Orcamarina Business Group www.orcamarina.org